Ivo Marloh

Edited by
Michael Sanderson

The DRONE Camera Handbook

Foreword by Emmy-award winning
Adventure Cinematographer

Keith Partridge

(Touching The Void, Human Planet)

Aurum
Press

Quarto is the authority on a wide range of topics. Quarto educates, entertains and enriches the lives of our readers – enthusiasts and lovers of hands-on living. www.QuartoKnows.com

First published in Great Britain
2016 by Aurum Press Ltd
74–77 White Lion Street
Islington
London N1 9PF
www.aurumpress.co.uk

Foreword copyright © Keith Partridge

A catalogue record for this book is available from the British Library.

ISBN 9781781316061

10 9 8 7 6 5 4 3 2 1
2020 2019 2018 2017 2016

Designed by
theurbanant.com

Printed in China

Front cover:
© iStock.com/Harvepino bearb (main)
© DJI (drone insert)
Back cover:
© Inu/Shutterstock.com (top); © Jag_cz/ Shutterstock.com (2nd top); © pisaphotography/ Shutterstock.com (3rd top); © DJI (drone insert); © Sunlike/Shutterstock.com (bottom)

Disclaimer

Ivo Marloh

The DRONE Camera Handbook

A complete step-by-step guide to aerial photography and filmmaking

The manual that should have come in the box

Contents

Foreword

Keith Partridge

Altitude: 4,400m (14,432ft). We'd puffed our way to stand on a fallen slab of granite, the only surface flat enough to act as a launch pad. Winds gusted and swirled off the surrounding glaciers and above us towered 'The Sphinx', a complex wall of rock almost three times the height of the Eiffel Tower. A keen eye could spot a small, yellow tent literally hanging just below one of the overhangs. In the cold, thin air the rotors had little to grasp onto and the battery's reactions were stalling – 95 per cent...85 per cent...65 per cent... Flight time had become critical. On cue, the tent's door unzipped and the drone flew away from our two Big Wall climbers, peering out at the prospect of another day, living in the vertical world. It was to prove a breathtaking reveal.

It is a perspective that only recently, with the rise of the drone, has become reasonably affordable in film terms. That is not to say that a helicopter equipped with a complex, stabilized camera mount is no longer relevant. I've flown in a 'paraffin budgie' to an altitude of 8,200m (26,896ft) while shooting with a Cineflex system – a height that, I suspect, is outside the operational limits of current drones. It was incredibly exciting – and we got the shots – but at what cost?

Now, equipped with the mindset of the commercial pilot, a well-maintained drone and the implementation of safe flying procedures, these diminutive machines will continue to lift above their weight within the modern arsenal of filmmaking wizardry.

And therein lies the rub. As with most new, exciting and game-changing inventions, there is a temptation to see drones as the panacea to all 'normal' cinematography ills. Typically this then leads to an era of endemic overuse of the new gadget, a time that is easy to pinpoint in years to come as the moment when drones went mainstream and mass market. Inevitably, overuse will dull their impact, and the magic wand of the drone will cease to work.

For a film to be successful, it has to affect the audience, creating impact and engagement. That never happens with beautiful visuals alone – story is still the glue that holds everything together and emotionally engages audiences. Within the filmmaking landscape there is huge scope for the drone to offer its unique capabilities and fresh perspectives. Learn its place in your story, learn to fly it safely and accurately and look on it as a powerful tool to add dynamic movement, reveal the true worth of a shot and fly us to places we've never seen before. But always well before the battery dies…

Keith Partridge
Emmy and Bafta award-winning
adventure cinematographer
(*Touching The Void*, *Wild Climbs*, *Human Planet*)

Introduction

With consumer drones becoming ever-more affordable, you might be thinking of getting your ten-year-old a quadcopter for Christmas. But we all know who's going to be hogging said present, and it isn't your ten-year-old.

Drones have gone mass market. And what's more, the easy availability of components, hardware and software means that if you come from a radio-controlled (RC) background, or if you have a little spare time, you can just build one yourself – including a 4k camera and stabilizing gimbal. The sky, literally, is the limit.

If you know anything about drones, you'll have heard of DJI Phantoms, or the French company Parrot that has revolutionized the toy drone market. Even over the last year, technology has come on so fast that nowadays, taking a few sick clips of your black-diamond ski run is just the beginning.

It's the Wild West out there

DJI have launched their Phantom 4, with 'point of interest' function, 4k camera and 'follow me' as standard, as well as a 'sense-and-avoid' function that protects the aircraft from flying into obstacles. Autel Robotics have launched their Kestrel fixed-wing drone, and the Chinese manufacturer Ehang have launched a drone with its own Twitter account. Although not relevant to this book, Ehang have also presented a prototype drone that can fly a person. That's right: your very own, air-bound scooter.

The drone market is the new Wild West of computer electronics. With mirror-less cameras becoming ever more compact and powerful, and stabilizing software and hardware becoming increasingly sophisticated, the quality of video and photography is getting significantly better every year – and the consumer drone market is still only a few years old.

How this book works

In the first half of this book, we cover everything you need to know in order to decide which drone would be best for you and your filmmaking needs, including all the major drone components you might need to build your own camera drone.

In the second half of the book we get into tried-and-tested filmmaking and editing techniques, including the difficult question of how to create and add meaningful sound – as opposed to just making pretty aerial music videos. These principles apply regardless of the quality and sophistication of your drone, so even

with ever-advancing drone technology, and even if you own a drone that's not mentioned in this book, you'll be able to put *The Drone Camera Handbook* to very good use.

For now you have Parrot, DJI, Fleye, Ehang, Yuneec and countless others to choose from for ready-to-fly drones. But this is just the beginning. Get involved with camera drones now so that you'll be at the forefront of aerial filmmaking in the near future. Don't wait until drones *really* take off.

1 Drone basics

Drones are taking over the world. This is not a cause for alarm, though – this new trend might just change your life. Job opportunities abound in a field that is rapidly evolving, so here are the basics on how to get in on the game.

In this chapter we'll discuss:
- What are UAVs?
- The drone market
- How drones work
- Which categories do drones fall into?
- Which drone is right for you?

What are UAVs?

Most people associate the word 'drones' with military surveillance and the war on terror – sophisticated, unmanned aircraft that fly invisibly at high altitude, stalking their prey for hours on end. This slight misnomer has become a catch-all term for all remote-controlled aircraft.

Above: The Ryan Model 147 UAV was developed from the earlier Ryan Firebee target drone series.

People have attempted to build unmanned aircraft vehicles (UAVs) for over 160 years. In 1849 the Austrians hatched the idea to launch balloons carrying explosives over Venice, to break the deadlock over the Venetian attempt to break free from the Austrian Empire. The lethal balloons didn't do too much damage, but the siege-suffering, starving population of Venice surrendered two days later.

The first drones

Sixty-five years later, during the First World War, attempts to use radio-controlled aircraft against Zeppelins resulted in the first automatic aeroplane, dubbed the 'flying bomb', which became a precursor of today's cruise missiles. The engineers used early-day gyroscopes to control the aircraft. Gyroscopes, or 'gyros', are used even today in modern drone technology.

During the Second World War, both the United States and Nazi Germany got serious about radio-controlled aircraft.

The technology was ever-more developed and expanded upon post-Second World War and during the Cold War. The US army developed unmanned reconnaissance drones for fear of having pilots shot down over the former USSR, and in order to spy on North Vietnam, Communist China and North Korea in the 1960s and 1970s. The first 'birds', the Ryan 147B drones, took routine flights during the Vietnam War, including parachute landings over Taiwan.

Battlefield UAVs

These early UAVs were still unreliable, but all that changed in 1982 when the Israeli air force successfully used unmanned aircraft against the Syrian air force. The drones were used as electronic decoys, electronic jammers and real-time video reconnaissance and helped to destroy a large number of Syrian planes with minimal Israeli casualties.

After using military drones in the mid-1990s

Above: The 2006 RQ-16A T-Hawk, a jet-propelled US army reconnaissance drone, suitable for backpack deployment and single-person operation.

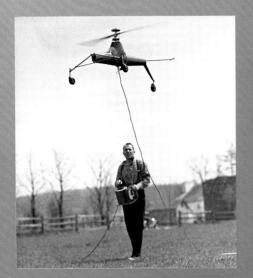

Above: Arthur M. Young controlling his very first model helicopter, which he built in 1941.

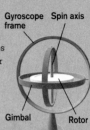
during the Balkans war, the US army greatly expanded their drone programme with the war in Afghanistan that began in 2001.

Nowadays, high-altitude, long-endurance drones, radio-linked to ground, sea, air and space platforms, are in full service.

Civilian UAVs

Once the emergence of drones had proven what could be achieved in unmanned flight, remotely piloted vehicles, or RPVs, also took off on an altogether different tangent in the late 1940s, when hobbyists started to develop their own, decidedly non-military use for radio-controlled aircraft.

As early as 1941, the American engineer Arthur M. Young developed the very first remote-controlled helicopter. After twelve years of working on his own, he took his rotor-based helicopter designs to the Bell Aircraft Company in Buffalo, New York and the company agreed to build a full-scale model.

As American involvement in the Second World War was looming large in 1941, Young worked in secrecy with a small team to develop the first helicopter prototype, the Model 30, in 1943. In 1946, the company issued the world's first commercial helicopter, the Bell Model 47, which was so successful that it was manufactured until 1974. It formed the basis for generations of helicopter designs. A modern version of Young's patented rotor stabilizer bar, also known as the flybar, is still in use to this day.

Enthusiasts around the world have been developing RC aircraft since those early days. Young's designs informed advancements in helicopter technology for decades; even today's hi-tech wi-fi drones owe their debt to him.

Below: The electric-powered E-flite Blade 400 3D helicopter from 2007.

Rise of the drones

In the last few years an altogether different drone trend has taken the tech-toy market by storm, and it has since revolutionized consumer cinematography and photography.

The consumer drone industry is now positively booming, with an estimated growth of 13 to 18 per cent annually. In most countries, especially in the big consumer markets such as the United States and Europe, the aviation authorities still haven't caught up, meaning that there are not yet any laws that clarify what can and cannot be done with a consumer UAV.

Above: A German police drone from 2012, equipped with camera surveillance for aerial filming and monitoring.

DJI takes the lead

Once the new drone and action-camera technologies were put together, this trend truly exploded and opened up an immense array of new possibilities for photography and cinematography. Most notably, the DJI Phantom 2 – a compact quadcopter capable of flying a GoPro 4k camera – combined the latest technology with affordability in such a successful way that DJI has since taken the lead in the consumer drone market.

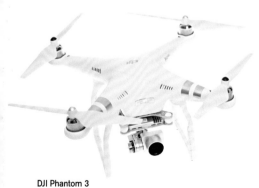

DJI Phantom 3

New, bird's-eye views

UAVs in aerial cinematography have been around for a lot longer, but these earlier camera-rigged UAVs were always in the realm of dedicated model builders and cinematographers. The true consumer drone revolution happened with camera technology becoming smaller and smaller over the last ten years. Suddenly the world is your oyster – if you can spot an oyster from 120m (394ft) up.

Computerized flight

The drone filmmaking trend hit a new breakthrough even more recently with the emergence of computerized flight-control technology and multi-rotor systems, the latter not being possible without the former.

All RC aircraft traditionally required a lot of skill to fly them well and safely, before you even equipped them with a camera. To be able to fly a camera they had to be fairly large, which made them very expensive – too expensive for most.

Waypoints and flight patterns

Unlike planes and gliders, with multi-rotors there are no rudders or ailerons, just multiple propellers that move independently and at different speeds and directions to steer and propel the aircraft. This requires a computer to control and modulate flight.

Equipped with GPS, optical flow and other guidance systems, it is now possible to fully automize flight, and even have the camera drone follow you down a ski slope – at a preset altitude and distance – to elevate your home-movie experience to a whole new level.

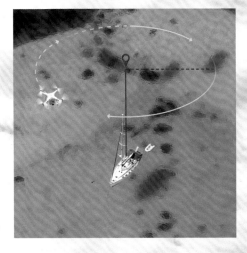

Below: A pre-mapped waypoint course around a lake lets you determine speed, altitude and orientation for each waypoint.

Above: DJI Phantom 4's point of interest (POI) function lets you tap a point on the controller screen to tell the drone to circle it.

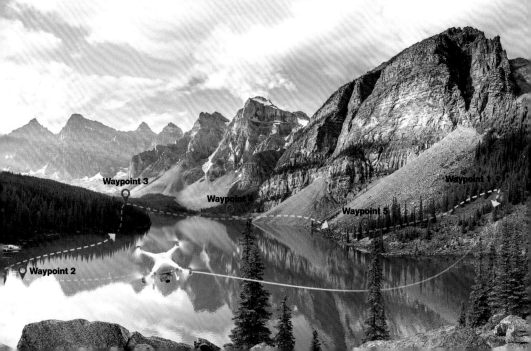

Waypoint 3

Waypoint

Waypoint 1

Waypoint 5

Waypoint 2

How do they work?

Most of the new consumer and prosumer drones share similar key components that enable them to perform all the common flight characteristics we now expect to see. The different price brackets then separate them further by quality and capability.

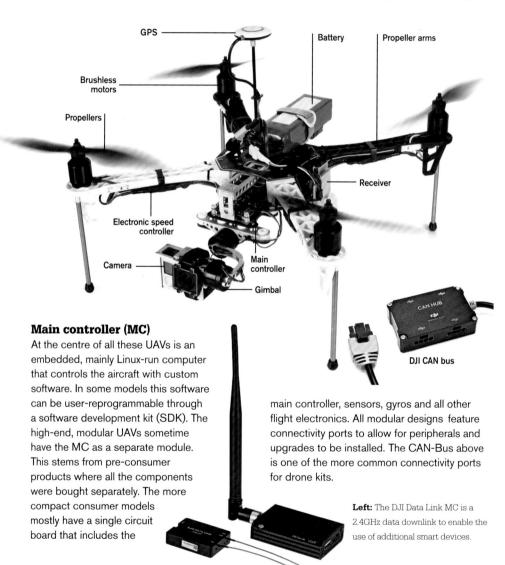

GPS

Brushless motors

Propellers

Battery

Propeller arms

Receiver

Electronic speed controller

Camera

Main controller

Gimbal

CAN HUB

DJI CAN bus

Main controller (MC)

At the centre of all these UAVs is an embedded, mainly Linux-run computer that controls the aircraft with custom software. In some models this software can be user-reprogrammable through a software development kit (SDK). The high-end, modular UAVs sometime have the MC as a separate module. This stems from pre-consumer products where all the components were bought separately. The more compact consumer models mostly have a single circuit board that includes the

main controller, sensors, gyros and all other flight electronics. All modular designs feature connectivity ports to allow for peripherals and upgrades to be installed. The CAN-Bus above is one of the more common connectivity ports for drone kits.

Left: The DJI Data Link MC is a 2.4GHz data downlink to enable the use of additional smart devices.

Gyros and sensors

The main controller tracks how the drone is flying by using sensors that include accelerometers for speed, and inertial measurement units (IMUs) to measure linear and angular motion with a triad of gyroscopes. This sounds very complicated, but in most consumer drones it is all integrated nowadays. These sensors tell the MC the direction, altitude, vertical and horizontal motion, and acceleration. A very similar technology is used to stabilize steadicams.

Receiver

The receiver receives all the information beamed up by the transmitter, which incidentally is the RC unit that the operator or pilot holds. The receiver normally has at least four channels for all pilot input, with spare channels to be used to change flying modes, or control additional modules such as landing gear or gimbal and camera control.

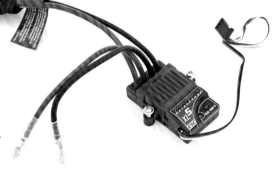

Electronic speed controllers (ESCs)

The ESC regulates the power input and output of the engine. More sophisticated models feature ESCs that will also monitor the performance of the engine, including error messages to be relayed to the receiver system, so that, should a rotor fail, you will still be able to land the drone safely.

Below: Sensors read the orientation of the aircraft in relation to the gimbal on 3 axis and communicate with the flight controller to counteract to movement.

Above: Designed by Traxxas, the completely waterproof XL-5 electronic speed control is a high-performance ESC packed with impressive specs that are normally only found on more expensive, high-end replacement units.

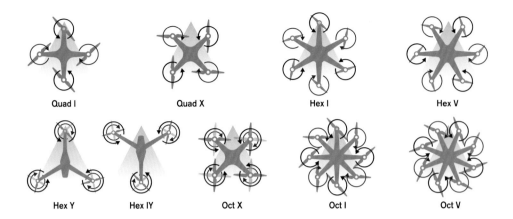

Quad I Quad X Hex I Hex V

Hex Y Hex IY Oct X Oct I Oct V

Propellers

Most consumer drones use plastic propellers. They are light and flexible and can easily be replaced if they break. Make sure to take a few spares if you go off on remote adventures. Bigger, professional UAVs sometimes use carbon-fibre rotors, but due to their rigidity they are also a lot more dangerous if something goes wrong. In the consumer and prosumer markets, these carbon-fibre rotors should not be used unless you are a very experienced pilot and need extreme performance out of your drone.

Above: These are the prop/motor arrangements for a number of multi-rotor types. Note the clockwise/anti-clockwise pairing of every two motors.

Motors

Drones are powered by simple, brushless motors that, once failed, can simply be replaced with a new one. There are either one, two, three, four, rarely five, six or in some cases even eight motors, depending on the size of your UAV. The motors are paired, one rotating clockwise (CW) with the second rotating counterclockwise (CCW), so it's important to use the correct rotational system if you were to replace one.

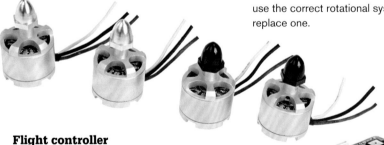

Left: Brushless electric motors are partnered in pairs of clockwise and anti-clockwise rotating motors.

Flight controller

The flight controller is the brain. It receives a never-ending stream of data from the array of sensors all over the aircraft, processes it and issues hundreds of commands per second to effect microadjustments in order to keep the aircraft stable. It can fly the aircraft autonomously on follow-me functions and it can take-off and land it as well.

Right: The more advanced AutoQuad 6 flight controller.

GPS

Increasingly, consumer and prosumer UAVs now have GPS positioning as standard. Marrying drones with GPS systems has now spawned a whole array of follow-me drones – that is, drones that follow their pilot at a pre-set height and angle and film you in the process. Your skiing pictures and videos will never be the same again. More common features of inbuilt GPS positioning include fixed hovering, auto return home, a safety zone around the pilot, hovering when out of transmitter range and orientation control. The GPS is paired with an electronic compass, similar to the one you might find on your smartphone, which will need calibrating every time you take your drone out.

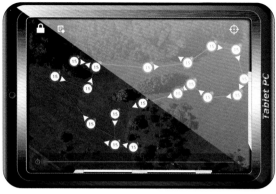

Above: Setting complicated routes with multiple GPS waypoints is just one of the many advantages of using GPS technology in multi-rotor drones.

Transmitter

The transmitter, also called the radio controller or RC unit, is where it's all done from the pilot's point of view. Most drones use dedicated RC controllers, but increasingly the more consumer-orientated, entry-level UAVs use a combination of mobile apps and wi-fi, effectively making your tablet or smartphone the transmitter.

With module-based UAVs, i.e. a UAV you assembled yourself, you need to be sure to use same-brand receivers and transmitters, otherwise you'll probably run into transmission problems. An increasing number of consumer and even prosumer models now have everything integrated and are known as 'ready-to-fly' (RTF) drones.

Transmitters can be anything from a simple, plasticky joystick toy to a large and sophisticated operation unit with inbuilt screen for your first-person view (FPV), telemetry data and even audio feedback. Some of these more high-end RC controllers are more complex than the aircrafts themselves, because it is in this unit that all the back-end magic happens.

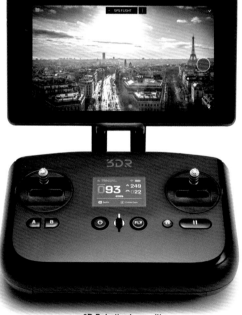

3D Robotics transmitter

Ground station

In its simplest form, the ground station is the device that runs the software to communicate with the UAV on a specific frequency, as well as the transmitter, smartphone or tablet via bluetooth or wi-fi. The software can also run on a ground-based computer that serves as the ground station, linked to the transmitter by bluetooth or wi-fi. It will show live data on the UAV's performance and position and can display the FPV video feed.

These days, the more powerful transmitters and receivers mean that ground stations come

into their own particularly when the drone is beyond visual range (BVR). This is where rules, regulations and the law are applied and need to be adhered to. Most authorities, like the FAA and CAA, won't permit BVR at all. Please check with your local authority before attempting anything like it. But even with the drone in visual range, flying it with the help of pre-set waypoints can be very useful for cinematography, for example when you need to repeat a certain take over and over.

Right: A digital video downlink such as the Yuneec MK85 is designed for the GoPro Hero3 and 4 and provides real-time image transmission that can be viewed live on the ground station.

Above: The generic ground-station setup, linked to all screen devices, as well as the transmitter and drone.

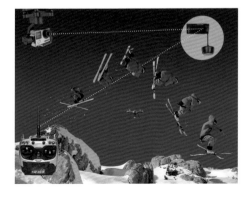

Optical flow

The optical flow function is designed to enable drones to fly indoors, or in any location that doesn't have a clear line of sight with the GPS satellites. Optical flow works with high-speed imaging to work out the drone's relative position, using so-called 'motion estimation'. It is the same as what you experience as you move through the world, and register with your eyes where you are relative to everything and everyone around you. Optical flow does not work in complete darkness, but the systems are now sophisticated enough to work in very low light conditions. Some drones, such as the DJI Phantom, also use ultrasonic emitters and microphones based on the way bats move in complete darkness.

Telemetry/OSD

The data generated during flight, showing everything from altitude, speed and battery life to 3D motion and range, is called telemetry data. If you have a screen for FPV on your transmitter, the data will be superimposed over the video feed. Telemetry still needs its own components, with a dedicated receiver and its own frequency.

Camera gimbal

The gimbal is a magic device that counteracts the considerable vibration caused by propellers and motors. By cutting out a lot of the drone movements, it helps you take perfect, smooth shots with your gimbal-stabilized camera.

The brushless gimbal is a motorized gimbal that stabilizes the camera as well as controlling the camera's angle and tilt.

Brushless gimbal systems are either two- or three-axis – nowadays three axes are most common as they stabilize roll, tilt and pan, giving you the smoothest video possible.

More professional systems might also be operated by two operators, one to pilot the drone on the instructions of the second operator who is in control of the camera camera via the brushless gimbal.

Above: DJI's vision positioning system, a slightly more advanced optical flow system, also utilizes ultrasonic sensors for more detailed ground mapping.

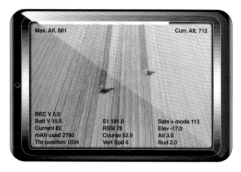

Above: Telemetry data is being superimposed over the FPV screen.

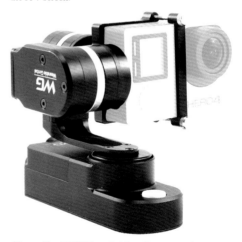

Above: The FY-WG 3 gimbal from Feiyutech offers exceptional stabilization technology for action cameras, such as the GoPro.

Drone categories

We can categorize drones according to price brackets and spec. This is very useful if you're trying to work out what you'll get for your budget, as well as establish what you want to do with your potential drone.

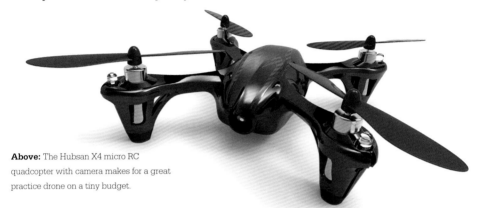

Above: The Hubsan X4 micro RC quadcopter with camera makes for a great practice drone on a tiny budget.

The question of quality/price/spec is an endless semantic debate that all the seriously gadget-obsessed tech-heads like to – well, endlessly obsess about. There are a few exceptions, but we can largely break down UAVs into three categories.

Consumer drones

As this is a book on camera drones, we're going to ignore anything that isn't carrying at least some sort of HD device. Consumer drones we're looking at here are also known as starter drones, still in the tech toy bracket, but with the addition of a camera.

The cameras used by most starter drones are mainly for some FPV fun and for showing off to your friends. They do, however, feature in-built cameras that are normally HD quality, mostly integrated in the tip or underside of the quadcopter. The available settings are limited, but they will do a nice job of recording your

flight and showing you the neighbourhood from a new angle.

Even though these starter drones all have cameras, they can't stabilize your video without camera gimbals. Therefore they aren't ideal if aerial photography is your main aim with a drone. There is nothing worse than capturing something with your drone that you know you'll never get to film again, such as wild animals in a reserve, or a friend catching that first big wave, only to then discover that your drone's vibration is so bad that the footage is virtually unusable.

Starter drones, on the whole, don't have GPS or more sophisticated flight systems for autonomous flight and follow-me functions, as these UAVs are mainly geared towards beginners who are looking to actually *fly* their drone, rather than professionals who will be more interested in autopilot functions so they can concentrate on their camera work. These

quadcopters often feature USPs such as one-button flips and other acrobatic manoeuvres, and are great starter drones in every sense of the word. You'll learn how to fly a copter and operate a basic camera proficiently without the risk of crashing a sophisticated, expensive flying machine on the first day out.

These starter drones are relatively cheap but some are remarkably solid as well, so you do get a lot of bang for your buck. What these toy drones lack in camera quality, they make up for in sheer flying fun for beginners. They are also invaluable in terms of gaining experience – they won't even mind if you crash them on your roof a few times (*see also* page 26).

Above: The UDI U818A toy-grade RC quadcopter with camera is another great toy drone to practise your skills on before you upgrade to a more sophisticated machine.

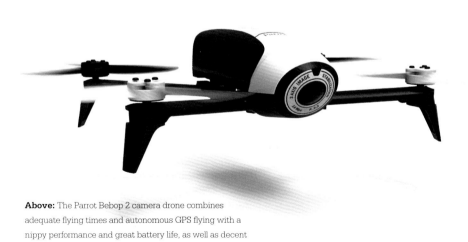

Above: The Parrot Bebop 2 camera drone combines adequate flying times and autonomous GPS flying with a nippy performance and great battery life, as well as decent video capabilities.

Prosumer drones

The prosumer bracket covers all the drones that are still affordable to both RC enthusiasts who'd like to try their hand at some aerial filming, and more professional filmmakers who'd like to incorporate aerial photography into their work, but don't yet want to shell out on much more expensive, larger UAVs for heavier camera gear.

Nowadays, prosumer drones are mainly quadcopters, with the exception of a few hexa-rotors specifically designed for video work. With the proliferation of the very lightweight GoPro cameras, the most common configuration is often a combination of a GoPro camera with a three-axis stabilization gimbal.

DJI Phantom 4s have integrated 4k cameras with three-axis gimbals as standard.

Prosumer drones don't meet the higher standards and requirements of TV and film professionals because of their limited payload capacities. They cannot, by their definition, carry full-size cameras, and are still limited in their stabilization technology, but they are a great way to start integrating aerial photography into your work.

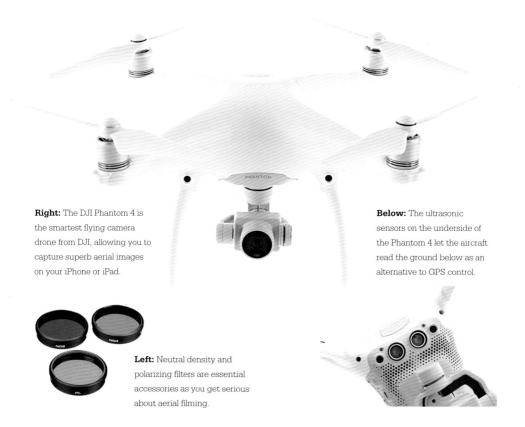

Right: The DJI Phantom 4 is the smartest flying camera drone from DJI, allowing you to capture superb aerial images on your iPhone or iPad.

Below: The ultrasonic sensors on the underside of the Phantom 4 let the aircraft read the ground below as an alternative to GPS control.

Left: Neutral density and polarizing filters are essential accessories as you get serious about aerial filming.

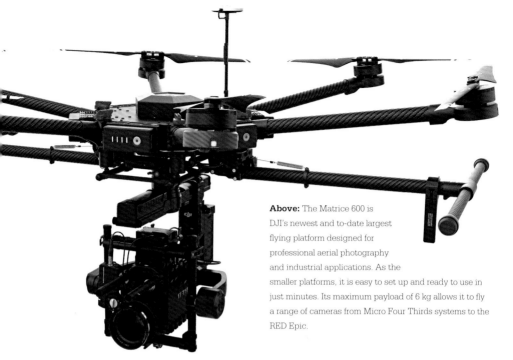

Above: The Matrice 600 is DJI's newest and to-date largest flying platform designed for professional aerial photography and industrial applications. As the smaller platforms, it is easy to set up and ready to use in just minutes. Its maximum payload of 6 kg allows it to fly a range of cameras from Micro Four Thirds systems to the RED Epic.

Professional drones

More advanced drones and professional UAVs include hexa-rotors, octo-rotors and anything above that. These drones are designed to be endlessly customizable and carry heavier payloads, such as DSLRs and cinema cameras.

These platforms can still be purchased through specialized retailers such as B&H and even Amazon, but they require a deeper knowledge of the technology, as you'll need to be able to maintain them properly yourself.

Thanks to ever-more compact, high-speed recording technology and the miniaturization of camera electronics, these days even the smaller professional drones will enable you to achieve professional cinema quality.

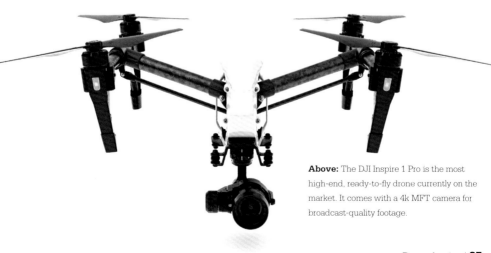

Above: The DJI Inspire 1 Pro is the most high-end, ready-to-fly drone currently on the market. It comes with a 4k MFT camera for broadcast-quality footage.

The right drone for you

When you set out to buy your first drone, your choice depends on your intended use. As a reader of this book, you're most likely an aspiring aerial imagist. As such, you should see a drone as an investment in your future profession, as well as, purely and simply, a tool.

A camera drone is only as good as its user, its camera and, most importantly, its gimbal (*see* page 50). Your choice will most likely come down to what quality of footage you want to get and what gimbal systems your UAV supports in order to fly the camera you need.

GPS drones

Flight systems that are GPS-based mostly support a return-home function, which is very useful, but by no means the only useful application for GPS. For instance, if you want to use your drone to film tracking shots of a moving subject, you will need a drone that can lock on to a subject's on-body GPS device, such as a smartphone or smartwatch. You might also like to track along a predetermined route. For this, you'll need a drone that supports a more sophisticated GPS waypoint system as well.

Below: The Parrot Bebop 2 combines aerodynamics, style and robustness in a lightweight and compact drone. It can shoot HD video and 14MP still photography.

Above: Fitting into the palm of your hand, the Revell X-Spy is one of the smallest and cheapest quadcopters, with FPV flight, adequate video and no assembly whatsoever.

Practice drones

If you are completely new to drone filming, and aiming for it to become a cornerstone of your professional output, consider buying a cheap consumer drone first, so you can get some practice. The flying principles are mostly the same, give or take a few more advanced functions, so if you start with a cheap drone it won't break the bank if you crash it. Also, as it is bound to be lighter than a prosumer drone, the risk of injury to unfortunate bystanders is a lot lower should your drone go astray.

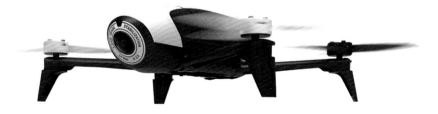

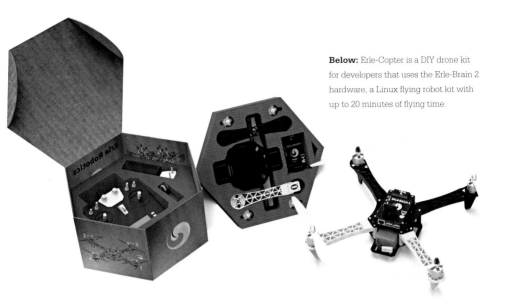

Below: Erle-Copter is a DIY drone kit for developers that uses the Erle-Brain 2 hardware, a Linux flying robot kit with up to 20 minutes of flying time.

Ready to fly (RTF) or build it yourself?

Consider your technical skills. If you have ever built your own RC models, then you'll be very comfortable customizing your own drone using off-the-shelf components and a GoPro camera. But if you're completely new to this, there are plenty of RTF drones to choose from, especially in the consumer and prosumer bracket.

Power-supply categories

Most drones nowadays use lithium batteries, which have very high energy density – high enough to let a UAV fly for a useful amount of time. Most consumer drones use the more common lithium batteries, but as they get larger (hexa-rotors and up), they tend to use lithium polymer (LiPo) batteries. These come as flat packs and require a hazmat certification to ship, which means that they are more costly to replace and transport.

If you're mostly happy to use prosumer-quality cameras you might want to consider a prosumer drone as your dedicated tool, and sporadically renting or hiring an owner-operator with a DSLR platform on an as-needed basis to avoid higher costs.

Right: A high capacity, high performance LiPo battery offers up to 12 minutes of flight time, depending on the weight of your drone.

2 Inner workings

You may well opt for a ready-to-fly drone so that you can start taking aerial footage as quickly as possible – and there is nothing wrong with that. But you should still have a look at the main components of a working quadcopter first.

In this chapter we'll discuss:
- The list of kit needed to fly a modern drone
- Camera gimbals
- Motors, propellers and batteries
- Weather protection
- How to build your own drone

First-person view (FPV)

After a lifetime of dreaming about being able to 'fly', new and ever-cheaper technology now enables us to view our surroundings from a bird's-eye view and be in full control of our movements. This can be a truly incredible experience, especially when you see your most familiar places from an entirely new angle.

The momentum of FPV has been building steadily over the last decade, but in the last two years it has truly taken flight, and you can now view in real time what your UAV 'sees'. This is a leap from the previous RC experience, which involved flying your aircraft always in line of sight (LOS). Now, with better FVP technology and longer-ranging transmitters, UAV pilots can experience flight through the camera of their drone, even when they have lost visual contact.

FPV or video recording, or integrated FPV recording?

Technology is moving quickly in this field, but at the time of writing both systems are still in use. Especially in the custom-built drone market, a lot of setups still require two cameras: a lower-quality camera for the FPV and a separate camera for video-to-SD-card recording.

This is because FPV requires a transmitter and receiver to send the live stream to your screen or goggles. Only a few systems

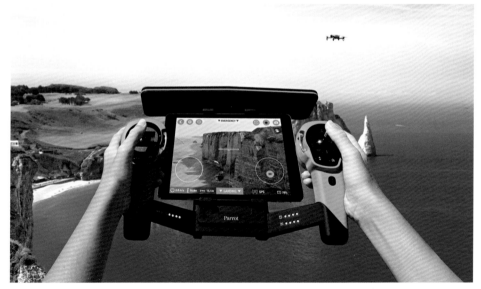

Above: The Parrot Bebop controller lets you monitor all telemetry data and fly your drone completely via FPV if you were to lose line of sight.

have yet mastered combining the two video streams, DJI's Phantom 3 being the standout frontrunner. More professional drones mostly require a two-person setup – a pilot to fly, and a cameraman for the camera.

Having said that, however, more and more prosumer camera drones now feature integrated FPV and recording systems, with which you can fly the drone via FPV, record it at the same time to SD cards, and use a single control-screen to view both the FPV and the camera recording. Within a couple of years this will be the new norm.

Below: A combination solution with a lower-resolution FPV camera and an HD camera for aerial filming.

Below: A complete FPV racing drone setup, with FPV monitor on tripod and two DIY racing drones.

Above: Outside daylight conditions can often be a lot brighter than you think, so a sun visor for your monitor is essential if you fly FPV.

Flying in line of sight (LOS)

Before you make the leap to FPV goggles and FPV-only flying, start by learning to fly your drone around your line of sight (LOS). This is a key skill to master before you go further afield and out of LOS. With the longer-range transmitters there is always the temptation to aim too far and high too soon, without knowing what to do if the autopilot goes wrong. Once you've truly mastered your drone in LOS, switching to FPV will open up a whole new and exciting world to you, a world that you wouldn't be able to reach with LOS alone.

Below: Flying manually and staying within line of sight is essential practice as you start out.

Monitor or goggles?

FPV goggles will give you the fully immersed experience of sitting in the cockpit of an aircraft. Some goggles come with head tracking, which will move the camera as you move your head – virtual reality at its most real.

Below: Fat Shark Attitude V3 FPV video goggles allow for first-person viewing of the video downlink from the drone transmitter.

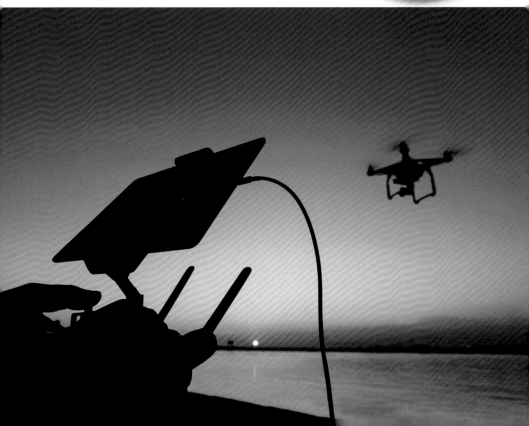

Above: FPV goggles are great fun, but if you want to get serious about aerial filmmaking, monitor flying is the preferred method of most professional drone pilots.

Goggles can be limiting if your main aim is aerial photography however, as nobody else will be able to see what you are seeing.

Using a monitor is a much better idea if you're mainly about aerial photography. You can share responsibilities with a co-pilot, so both of you can look up at the drone as well as see on screen what your camera sees, and discuss angles and movements as you go.

Glasses

If you like the idea of immersion but still want to retain LOS with your aircraft, FPV glasses are a great alternative. A new trend in FPV smart glasses, such as the market-leading Epson Moverio BT-300, seamlessly blends digital content into your field of vision, allowing you to maintain LOS with your aircraft.

These glasses feature 360-degree head-movement tracking sensors, integrated front-facing cameras for augmented reality and even dual display for 3D content. The last two features won't concern you for now, but with the rapidly evolving drone technology, integrated 3D cameras are not far off.

Above/below: The Epson Moverio FPV glasses boast an impressive amount of advanced technology, including a built-in camera, gyroscope, GPS and other sensors.

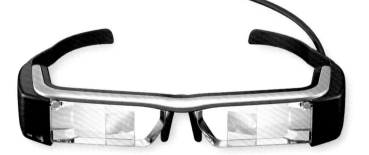

Monitors

The line between RC and FPV monitors on the one hand, and smartphone or tablets on the other, is getting increasingly blurred. All drones nowadays have their own apps that run either on a remote control or on your smartphone, but quite often, dedicated RC monitors still have their advantages.

Some, but by no means all, RTF drones nowadays come with their own RC transmitter-monitor. If you own one of the drones that do, you'll probably find that the monitor has superior picture quality to a smartphone or tablet, as it is larger and the LCD screen invariably fares far better with sun glare.

If your drone came with an app for your smartphone but no monitor, consider buying it separately if you find that the reflective screen of your device makes it hard for you to see your FPV or live video stream. There is nothing worse than not being able to properly see what you are filming – or worse still, to not be able to see where you are flying if you are not in LOS. Using your smartphone, another good setup is buying a separate monitor hood for it to cut out glare.

Above: A lot of modern drones come with flight-control apps that run on your smart device.

Menu

Settings Flat trim

Emergency landing Video record button

Flips options Still photos

▼ EMERGENCY ▼

Camera/satellite view

Control pad:
Go up/down
Rotate right/left

GPS signal

GPS

▼ LANDING ▼

84%

Take-off/landing Digital tilt control of the cameras Battery

Left: With a larger screen size, a tablet allows you to see a lot more than a smaller smartphone.

FPV goggles

Although FPV goggles have been around for a while, they've really taken off in the last four years with the boom of the multirotors. With their two small screens, one for each eye, they give you a truly immersive flying experience that some find very exciting, and others just too overwhelming.

The top brands for goggles are Fatshark, Skyzone and Boscam, and all three are known for innovative technological advancements.

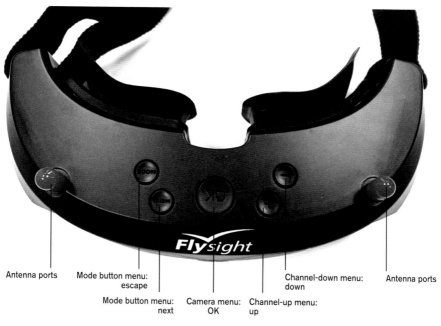

Antenna ports Mode button menu: escape Mode button menu: next Camera menu: OK Channel-up menu: up Channel-down menu: down Antenna ports

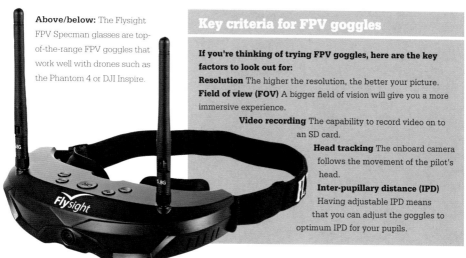

Above/below: The Flysight FPV Specman glasses are top-of-the-range FPV goggles that work well with drones such as the Phantom 4 or DJI Inspire.

Key criteria for FPV goggles

If you're thinking of trying FPV goggles, here are the key factors to look out for:

Resolution The higher the resolution, the better your picture.

Field of view (FOV) A bigger field of vision will give you a more immersive experience.

Video recording The capability to record video on to an SD card.

Head tracking The onboard camera follows the movement of the pilot's head.

Inter-pupillary distance (IPD) Having adjustable IPD means that you can adjust the goggles to optimum IPD for your pupils.

Transmitters

If you're planning to put your own UAV together or fly with your own transmitter, you want to know how to choose a good RC transmitter. This mainly comes down to functionality, number of channels and modes.

There's not really much to customize with transmitters, so it's a question of looking at what's commercially available and what's best suited to you.

Channels
Channels control each action the drone takes – one channel for one type of action. Throttle (lift) takes one channel, pitch (forward/backward) uses a second channel, yaw (left/right) uses a third, and roll (bank left/right) uses a fourth channel. A quadcopter uses at least four channels, but you'll need more for camera, gimbal, GPS and FPV.

Above: The XG14 'tray' transmitter is known for its amazing build quality, but you'll need to source a separate monitor for your aerial filming.

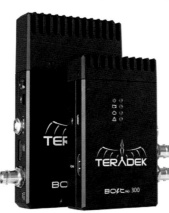

Right: The Teradek Bolt 300 is a zero-delay wireless video transmission system that transmits uncompressed 1080p60, 4:2:2 video up to 620m (2,000ft) – with its internal antennas and its compact size, it's the ideal add-on video transmitter for drones.

Receivers
If you buy your own transmitter rather than buying a drone that already comes with a dedicated one, this transmitter may come with a paired receiver. These are often only compatible with same-brand transmitters, so if it breaks you may have to find the same receiver again. This is mainly applicable to self-assembly drone kits.

Frequencies

Transmitters are normally capable of running on multiple frequencies and can be coupled with a lot of different receivers. Importantly, the aircraft must be controlled on a different frequency to the FPV downlink to avoid interference between the two systems. Normally these frequencies are 2.4GHz for the drone controls and 5.8GHz for FPV. This can also be swapped around, though.

Lower frequencies can pass through solid obstacles such as walls and trees, and thus have a much better range. However, due to restrictions we are only allowed to use 2.4GHz and 5.8GHz for drone transmitters.

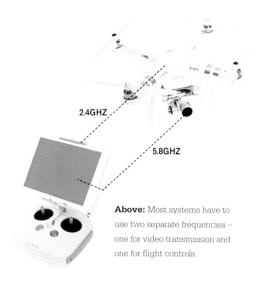

Above: Most systems have to use two separate frequencies – one for video transmission and one for flight controls.

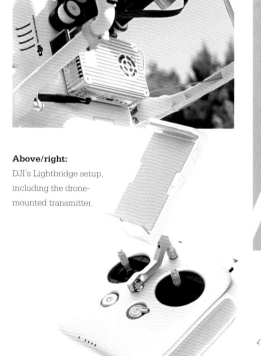

Above/right:
DJI's Lightbridge setup, including the drone-mounted transmitter.

DJI Lightbridge 2

DJI Lightbridge 2 is the dedicated DJI software that enables users to stream full HD video live from their drone to their receiver in real time.

The intelligent transmission system automatically adjusts channel and bandwidth for maximum video quality and minimum latency, down to as low as 50 milliseconds, and increases transmission range to up to 2km (1.2 miles).

The ground system is integrated into the remote control, making it incredibly easy to launch, and the new DJI GO app allows for precise control over your aircraft, while displaying a live HD view on your paired mobile device. You can also add secondary devices to control camera and gimbal movement separately, allowing a two-person crew to fly and film separately.

Antennas

One of the most important components of your drone setup is the antenna. There are different kinds of antenna depending on your needs and it is important to understand the differences, especially if you fly with a self-built or modified system.

The two main types are directional or omnidirectional, with either linear or circular polarization.

All drone antennas are tuned to either 2.4GHz or 5.8GHz, and you can only use them with equipment tuned to the same frequency. Even though there are more frequencies available, the majority of FPV antennas use the 5.8GHz frequency. Most FPV gear nowadays uses 5.8GHz since it is legal for FPV use in most parts of the world. Depending on where you are located, you can also use 900MHz (popular in the USA), 1.3GHz, or 2.4GHz to transmit your FPV video signal.

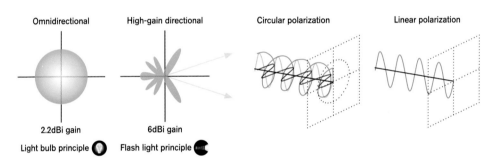

Omnidirectional	High-gain directional	Circular polarization	Linear polarization
2.2dBi gain	6dBi gain		
Light bulb principle	Flash light principle		

Omnidirectional antennas

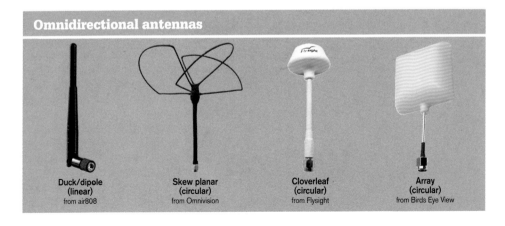

Duck/dipole (linear) from air808	Skew planar (circular) from Omnivision	Cloverleaf (circular) from Flysight	Array (circular) from Birds Eye View

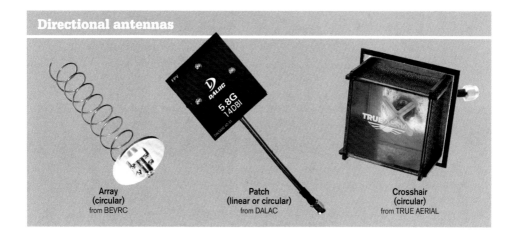

Array
(circular)
from BEVRC

Patch
(linear or circular)
from DALAC

Crosshair
(circular)
from TRUE AERIAL

Circular or linear polarization

The two main types of antenna are linear or circular polarized antennas. Linear polarized antennas form the signal on a single plane. Circular polarized antennas work in tandem to form a circular, corkscrew-shaped signal. The linear signal can reach further, as the energy is focused on a single plane rather than being dispersed, but the antennas need to line up in order for this to work well, and with a drone being in constant motion this can be a problem.

Circular antennas get far better reception due to the corkscrew shape of the signal, which has constant overlap, irrespective of what angle the drone antennas are flying at. This type of antenna is by far the most popular in drone systems.

Directional or omnidirectional

Linear and circular antennas can be both directional and omnidirectional. The main difference is that directional antennas have a longer reach at the expense of width of signal (less coverage), and omnidirectional antennas have a wider signal (greater coverage) but shorter reach.

Omnidirectional antennas provide great coverage for normal drone use, and you do not need to keep your antennas pointed at the drone. Directional antennas are much more high gain but need to be pointed at the drone, within LOS.

Multi-antenna receivers

Some FPV setups combine multiple types of antennas for better range, using omnidirectional antennas for good coverage combined with high-gain directional antennas for longer reach in a specific direction.

In order to the get the best signal, some receivers use two different types of antennas, for example an omnidirectional antenna for good medium-range reception, and a linear antenna such as a Yagi for longer reach. The diversity receiver analyzes the signal from both antennas and switches between them to get the best reception.

Dedicated video or FPV?

There are three options when it comes to drone cameras: dedicated FPV cameras for the best FPV experience but low video quality; a two-camera setup with FPV camera and a dedicated video camera for the very best video quality; or an all-in-one video and FPV camera for good video quality.

With rapidly evolving camera technology, and the ability to transfer ever larger amounts of data at ever faster rates, the question of which combination is best for you will very soon be irrelevant. Every drone will have a 4k camera with the fastest data downlink and the lowest latency.

Dedicated FPV

The dedicated FPV camera will give you the best flying experience, but by far the lowest-quality footage. It isn't mounted on a gimbal, and because it tends to point ahead rather than down, it will give you a much more direct sense of the aircraft's motion. FPV cameras are also a lot cheaper and lighter than dedicated video cameras, which will have a positive impact on your drone's battery life.

There's also the option of a twin camera setup to give you a 3D effect and make the FPV experience even more exhilarating.

Hires video/lowres FPV

This is the most common setup with more professional and larger drones, but it generally requires a pilot and a cameraman. Once you fly a DSLR or even larger cameras, you need to have a dedicated camera operator who knows how to work the camera and gimbal, and who therefore won't also be able to fly the quad.

Above: A dedicated FPV camera such as the Fat Shark PilotHD is great for the FPV experience, but can only film up to 720p.

Above: A GoPro Hero4 is a great add-on aerial camera with up to 4k resolution, but you won't be able to use it as an aerial camera as well as FPV at the same time.

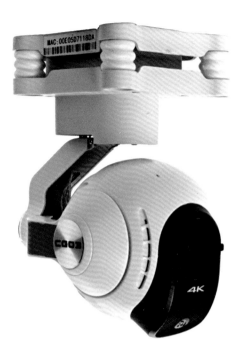

CGO3

4K

Above: The CGO3 4k camera on a three-axis gimbal is Yuneec's great alternative to DJI's 4k cameras.

Latency

Latency – or lag – is not a big deal if you use your drone mainly for filming at low to medium speeds, but if you're looking to race your drone at high speeds, latency – or the lack of it – is all important.

FPV camera latency is caused by the amount of data coming through your video feed. Top-end cameras such as GoPros or DJI cameras record high-resolution footage of up to 4k while live streaming to your FPV device. The amount of information to be processed is a lot higher than that of a simple low-resolution FPV camera, which is why high-resolution cameras cause much higher latency.

Connex zero-latency video downlink

This is the most costly and cumbersome setup, but it will give you the best video results. It should only be attempted once you've made the transition into a professional aerial photographer.

Hires video-FPV combo

With ever-faster advances in camera and gimbal technology, the all-in-one setup is fast becoming the norm. There are more and more platforms that feature a high-resolution action camera on a gimbal as standard, and most people won't be able to do better than the DJI Phantom 4 footage, which is of stunning 4k quality and silky smooth thanks to the integrated gimbal.

With non-integrated cameras, a GoPro Hero on a gimbal, doubling as video camera and FPV feed, is a very common alternative.

Opinions vary as to which camera produces better-quality footage, but both are 4k and the differences nowadays are marginal.

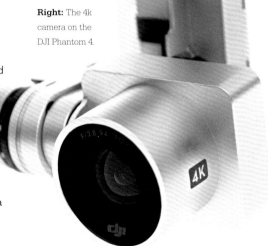

Right: The 4k camera on the DJI Phantom 4.

4K

Brushless motors

Brushless motors are at the heart of the new drone-technology boom. Without these ultra lightweight and ultra small little marvels, quadcopters would not be where they are now.

T here may well be a little too much geeking out going on here, but as an aspiring aerial filmmaker you should still know about what makes your drone fly, even though you may well want to go straight for the great, RTF, out-of-the-box options on the market today.

How do they work?

Each propeller of your drone is directly connected to a dedicated, brushless DC motor, and all motors are individually controlled by the electronic speed controller (ESC). This allows for the finest adjustments in lift, speed, acceleration and stabilization.

Brushless DC motors build on the legacy of brushed DC motors, which have been around for over a hundred years. The big difference is that brushed motors rely on 'brushes' – actually magnets – that touch the spinning shaft of the motor. This process is very reliable but, because there is physical contact, there is also wear and tear.

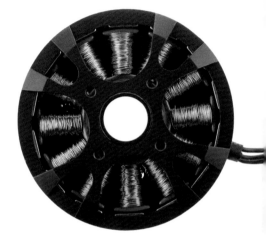

Above: A larger brushless outrunner motor for use as a gimbal motor in conjunction with a high-end camera.

Brushless motors were first manufactured in the 1960s and more recently found their way into RC aviation. They are a lot more advanced,

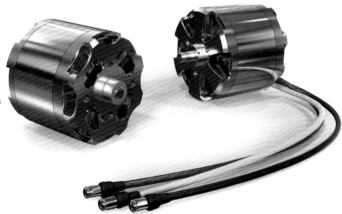

Right: Constructed from high-precision CNC-machined components and with powerful 40UH high-temperature magnets, this type of brushless motor is used for many multi-rotors.

and need the sophisticated electronics of the ESC to control them. There is no physical contact within the motor – hence the term 'brushless' – which means that they are a lot longer lasting and more efficient than their brushed predecessors.

Brushless motors are much more expensive than brushed motors, but they are also a lot smaller and lighter and, crucially, they are a lot more durable.

The main components

A brushless motor works by using an external, permanent magnet rotor, three phases of driving coils – which is why it has three wires – and an effect device that senses the position of the rotor, as well as the ESC. The coils are activated one phase after another by the ESC, which in turn gets its signals from the effect device.

Above: The brushless motors are mounted right below the propellers and are easily replaceable should they fail.

The two main components are the outer rotating rotor with mounted magnets, and the inner stator, a static electromagnetic device. This type of brushless motor is called an outrunner motor, due to the rotor being the outside part.

Multi-rotor aircraft only use outrunner motors, as they create the higher torque needed to drive the propellers. Inrunner motors, which have the rotor on the inside, can spin faster due to the smaller-sized rotors, but generate less torque. These are mainly used for RC cars.

Range and battery life

One of the biggest issues with today's out-of-the-box drones is the limited battery life. Short battery life means short flight time and range. This is not a big problem for anyone just starting out with aerial photography, but it can become a headache once you start going further afield.

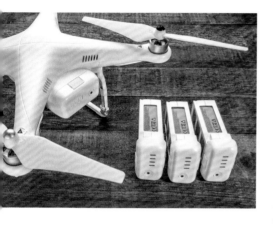

Left: Keeping a few spare batteries to hand will prolong your filming day and ensure that you get the shots that you might otherwise miss.

a couple of good takes in the can, but if you're filming somewhere tricky, such as off a boat or a cliff, you also need to factor in the time it takes to bring your drone safely back home.

Spare batteries

The most obvious solution to short battery life is to take spare batteries. The higher-end drones mostly feature removable batteries, which allows you to carry spares. As charging times are often in the range of 90 minutes and can only be done in the car or once you're back home, it can become very important that you are able to swap in charged batteries instead.

Even though a lot of prosumer drones are advertised with flying times of over 20 minutes, the reality is that once you factor in camera weight, weather conditions and battery-sucking apps, battery life quickly reduces to below 15 or even ten minutes. Ten minutes is still plenty of time to get

Cheaper consumer drones usually have built-in batteries that need to be charged inside the drone, so they don't give you any additional flying time. This is definitely something to consider when you're looking to buy your first drone.

Left: Don't charge your batteries too far in advance – they start losing charge slowly from the moment you take them off the charger.

PHANTOM
Intelligent Flight Battery

4480mAh
(68Wh)
15.2V

Below: All LiPo cells expand at high levels of charge or over-charge, due to slight vaporization of the electrolyte, so avoid over-charging.

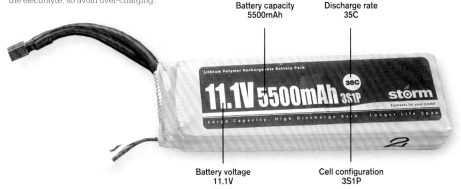

Battery capacity
5500mAh

Discharge rate
35C

Battery voltage
11.1V

Cell configuration
3S1P

Higher mAh

If you opted for a drone with a removable battery, try and find suitable batteries with higher mAh – milliamp hours – which is the available current that can be provided by the battery for one continuous hour. You can often add a considerable percentage of battery life and flight time in this way. But there will come a point where the additional weight that the higher mAh brings will have a negative impact on your flight time, especially if you're also flying a larger camera.

Make absolutely sure that your drone can handle the mAh of your substitute batteries before you purchase them. Be sure to read the drone manual carefully!

Tip

Make sure to carry spare batteries for your controller. With FPV and camera monitoring you'll burn through your batteries very quickly.

How to extend battery life

If your user manual gives a flight time of 15 minutes, it is unrealistic to hope that you'll be able to extend it to 25 minutes. But there are still a few things you can do to help your battery's life.

1. Initially, as you learn to fly your drone, leave the camera off if possible. It will save weight and add up to 10 per cent battery/flight time.

2. If you fly a larger camera, your drone might benefit from larger propellers. Experiment with a few sizes and note down achieved flight times.

3. Avoid windy or rainy weather – it means more work for your drone to stay stable. This has a negative impact on your flight time.

4. Don't completely drain LiPo batteries and don't overcharge them. This will shorten their overall life by up to 30 per cent.

5. Rechargeable batteries incrementally lose charge, even when not in use. Charge your batteries hours – not days – before you intend to use them.

Auto-follow systems

Until recently, it wasn't exactly easy to grab footage of yourself doing your adventure sports thing – especially on your own. Now, ever more drones feature auto-follow systems that follow you at a predetermined distance and height, by logging on to your on-body GPS transmitter. Is this the future of drones?

The drone 1.0 era is coming to an end. Joystick-piloted multi-rotors that take a lot of skill to fly, and have their roots in the RC enthusiast era, are making way for more autonomous systems that do everything you ask of them at the click of a button.

The drone 2.0 era

The challenge in making multi-rotor consumer drones mass market lay in pricing, and in the idea that it was somehow very niche. Those challenges were overcome by making control systems more user-friendly, and prices began to creep down – or perhaps they levelled out, but the drones got better and better in the meantime.

Now, a whole new generation of quadcopters is coming to the market, led by the DJI Phantom 4, the new 4k GoPro Karma, the Hexo+, the DJI Phantom 3 and the 3DR Solo in the last two years. All these feature similar kinds of auto-follow systems.

On-body control

Auto-follow systems work by logging on to your on-body GPS transmitter-controller. You pre-set your drone's altitude, distance and angle, launch it, and then set off on your activity of choice. Unless you get into a car, most of these drones will be able to keep up with you regardless of whether you ski or board down

Since 2015 the majority of drones have used both the American GPS (global positioning system) and the Russian GPS-alternative GLONASS system (*globalnaya navigatsionnaya sputnikovaya sistema*). Adding GLONASS to GPS devices such as smartphones or drones makes a lot more satellites available, which means that positions can be fixed even faster and more accurately.

Above: The Hexo+ is controlled by an app on your smartphone, which uses autoflight modes to follow and film you.

a mountain, hurl yourself down a ravine on a mountain bike, or catch those backcountry rapids you've been dreaming of in your kayak.

Your drone will keep up as long as it has battery life. Make sure you allow plenty of flight time to get back to a point from where you can retake control of your drone and land it safely before your battery runs out.

Left: The high-end AirDog drone features tailored, fully autonomous flight modes for action sports, fold-up arms for compact travel and fast and easy control with its dedicated tracking device (far left).

Weather protection

Once you have mastered flying and filming in fair weather, you'll inevitably be drawn to experiment with more adventurous conditions. But can you fly a drone through thick fog, heavy rain or a blizzard?

The large majority of drones are probably not equipped to fly through anything worse than a quick summer drizzle. Experimenting with a cheap toy drone is obviously preferable to risking a top-end aircraft, but apart from risking your aircraft, there's also the potential damage to your camera to consider in case of a crash.

Just don't do it!

Most drones are not made to fly in wet conditions. They often have vent slits on top to cool the motors, and once droplets form on the body there is a real danger that they will get into the electronics, resulting in shorts. Almost all manufacturers warn you not to take drones out at all unless it is dry.

If you fly your drone through fog, condensation forms on the coated body, running the risk of seeping inside. Within minutes the camera fogs up, rendering your footage unusable very quickly.

On the other hand, if it starts to rain while you're flying, don't crash your drone in panic. There's time to bring it home safely. If you do get it wet, make sure to dry it out properly and thoroughly – use a hairdryer to speed it up. Make sure to dry the motors, coils and bearings, otherwise they might seize up subsequently. Once you've dried out the drone, test it at a low level to make sure that it runs well.

Tayzu Robotics' waterproof drone

Tayzu Robotics' Quadra line of quadcopters delivers more functionality and strength than any other compact quadcopter on the market. Designed for GoPro cameras, the Quadra's waterproof design enables it to fly in wet weather, as well as being able to take off and land in water. With a waterproof camera case, you can start filming underwater before lifting out. Not bad for a compact mid-range drone.

Tayzu Robotics Quadra waterproof drone

Nano-coat waterproofing

The relatively new process of nano coating uses hydrophobic technology to coat even the tiniest electrical part in a water-repellent, invisible coat. Liquipel is one of a few companies that has started applying this technology to drones – they even offer a one-year guarantee. It's only a matter of time before the big drone manufacturers adopt this technology for the mass market, as has already happened with some smartphones, tablets and watches. Look up a nano-coat service in your area if you are serious about getting your drone waterproofed.

Below: After being completely submerged, a nano-coated, fully waterproof Phantom 2 flies on unscathed.

Below: Don't fly your drone in adverse weather conditions unless you have taken measures to waterproof it.

But if you really must...

It is never a good idea to fly your drone through heavy rain, but there are definitely shots worth taking some risks for. (Disclaimer: If you disregard the manufacturer's advice, you do so at your own risk!) Imagine the footage you could take flying through a snow flurry, foggy sunrise or the steam of a hot spring. Plan out your shot carefully before you launch, be sure you know exactly what you're doing, then grab that shot quickly and land your drone as soon as possible afterwards.

Gimbals

At the heart of a modern camera drone is the device that has revolutionized drones in the last few years – the three-axis brushless camera gimbal. It uses a lot of the same technology for stabilization as the drone itself uses to stabilize its flight.

T he idea of the gimbal has its origins in antiquity, and was first developed to keep ship instruments such as gyroscopes, compasses and stoves upright at all times with respect to the horizon, independent of the rolling and rocking movement of the vessel. Similar applications were later utilized in commercial aviation.

Above: The DJI Zenmuse camera gimbal for MFT cameras offers a stabilization unlike most gimbals on the market.

The three-axis camera gimbal

A gimbal is a pivoted support that allows your camera to be rotated on a single axis. A set of three gimbals, one mounted inside the other, enables three-axis control. The innermost gimbal remains independent of the rotation of its outer support.

Powered by three brushless motors, the three-axis gimbal is used to keep the camera level on all axes (up/down, left/right, forward/backward) and cut out vibration and shake. An inertial measurement unit (IMU) electronically responds to movement and the three motors react separately to counteract it.

A well-adjusted and fast-working three-axis gimbal makes all the difference between unusable footage and silky-smooth shots. This is why, once you have completely mastered flying your drone, you can happily use it for a lot more than just aerial shots:

dolly-, tracking-, trucking- and follow-shots are just the beginning (*see page* 112). Incidentally, the same three-axis brushless technology is used in handheld Steadicam technology.

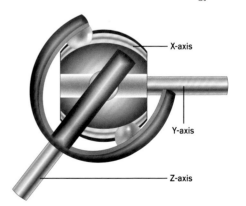

X-axis

Y-axis

Z-axis

Above: A set of three gimbals mounted together on three axes, each controlling roll, pitch and yaw.

How does it work?

In short, the IMU translates mechanical forces into electronic signals that can then be fed via the gyroscopes into the controller. The controller then sends out hundreds of commands every second to the three-axis gimbal in order to stabilize the camera. Translated into words, this would be something like, 'Tilt a little more left… a bit more… and back a bit… and a tiny bit to the right' – a never-ending string of electrical impulses. These commands not only keep the camera level, they also cut out a lot of the vibration caused by the rotors and forces of gravity.

Most electronic components are purely electronic without any moving parts, but IMUs do have moving structures that respond to

Above: Gimbals are very fragile devices, so a plastic gimbal bracket helps to secure the gimbal and camera during transport.

g-forces and the forces of gravity, and in so doing they measure each miniature impact. The IMU sends signals back to the controller, detailing the exact forces and direction.

The onboard computer – the controller unit – translates these signals into the commands being sent out to the gimbals.

Choosing the right gimbal

If you don't own an all-in-one camera drone and want to fly a separate camera, here are a few pointers on how to choose your gimbal.

Numbers of axes
Even though they are more expensive, always go for three-axis. Two-axis gimbals don't compensate for some movement and you'll regret not having three-axis support.

Remote control
Make sure that your gimbal is compatible with your drone, so that you can control the camera movements remotely.

Camera support
Your gimbal needs to support your camera. If you plan on flying a larger camera, you need a more powerful gimbal to support the weight. Equally, if your gimbal is too heavy for your camera, it won't work properly. Make sure that the two are compatible.

Calibration
Calibrating a gimbal is not easy. Try and purchase a gimbal that is pre-calibrated for your camera. If the gimbal was built for your specific drone, it should be pre-calibrated, but be sure to check.

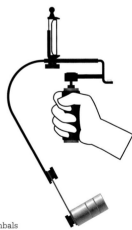

Right: Weighted camera gimbals were used in Steadicams long before they were adapted for drones.

Ground-station setup

Your ground station is the hub that communicates with your drone. If you own a ready-to-fly drone such as the Phantom 4, then your setup will probably be very simple and quick. If you have customized your system, then it's useful to know how a ground station works.

The main functions of the ground station are the telemetry and FPV feed, and to control your drone remotely from where you are. The setup differs considerably depending on what system you own and how integrated it is, but the main components are the same, even if you don't have to set them up yourself.

Ground-station setup

The bare bones of the ground station are a receiver, a monitor and/or goggles and the antenna. A lot of RTF drones nowadays come with an all-in-one unit, with the additional use of your smartphone or tablet as the monitor.

With this setup you will be able to control

Below: 2.4GHz and 5.8GHz are the most commonly used frequencies, but different combinations could be used depending on your equipment and the applicable laws in your country.

Right: A fully-integrated FPV setup within a waterproof case.

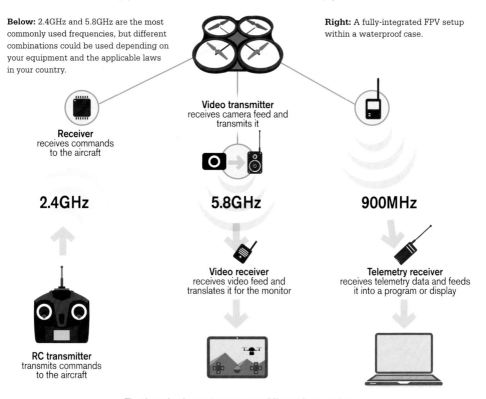

Receiver
receives commands to the aircraft

Video transmitter
receives camera feed and transmits it

2.4GHz

5.8GHz

900MHz

RC transmitter
transmits commands to the aircraft

Video receiver
receives video feed and translates it for the monitor

Telemetry receiver
receives telemetry data and feeds it into a program or display

The three feeds must operate on different frequencies

Left: The FPV video screen doubles up as a route mapper to plot a waypoint flightpath before take-off.

your drone remotely and stream the FPV video transmitted by the drone. Remember to bring spare batteries for your receiver unit and antennas.

If you use goggles, don't over-complicate your setup as you will not be able to look at it while your drone is in the air.

In addition to the basic setup, you can opt for a diversity module to use two types of antennas, an antenna tracker to adjust the direction of your antenna for long-range antennas, and a separate monitor for your camera video.

Telemetry

The most important data you use for your ground station is telemetry. This is the data sent between the drone transmitter and the ground station, including battery charge, altitude, direction, GPS and GLONASS data, wind speed and more, depending on the type of drone.

All this data will be analyzed by your application and can be overlaid onto your FPV feed (*see also* page 40). It will be included as standard with most prosumer drones.

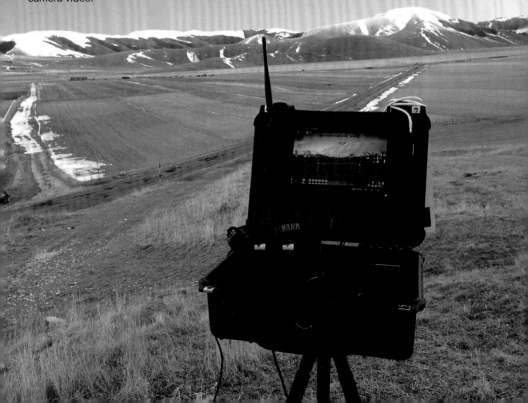

Build your own drone

You don't need to be a rocket scientist to build your own UAV, but the ability to use a soldering iron and follow a set of instructions diligently is a good start. The learning experience also comes in handy when you're filming in the back of beyond with no access to the internet or any spare parts (it happens…).

Drones typically fall into four categories: ready-to-fly (RTF) drones, almost-ready-to-fly (ARF) drones, all-inclusive kits and scratch builds. Additionally, the first two share a subcategory called bind-and-fly (BNF) drones – drones that need to be paired with a controller you already own.

Almost-ready-to-fly (ARF) kits
An ARF kit is the next step up from RTF. Frame, motors and other core parts are already assembled, but a few components have been left off for ease of packing and shipping. Some ARF kits don't come with a transmitter/receiver, flight controller or battery and charger, so you'll have to source those. You'll have to do some research to ascertain what is compatible. After assembly, you'll need to calibrate all parts.
Pros: Great quality alternatives to RTF available; highly customizable.
Cons: Often, controller and transmitter/receiver will have to be sourced separately.

Best ARF kits:

3D Robotics Iris+ ARF kit
- Easiest to assemble and very durable.
- Longest flight time (20 minutes).
- Flies GoPro Hero-size action cameras (*see also* page 69).
- Add flight controller, battery, charger and a transmitter/receiver.

DJI F450 Flamewheel QuadCopter ARF kit
- Best consumer-level kit on the market.
- Flies GoPro Hero-size action cameras.
- Add flight controller, battery, charger and a transmitter/receiver.

DJI F550 Flamewheel Hexacopter ARF kit
- Best prosumer-level kit.
- Flies GoPro and MFT cameras (Panasonic GH4, Sony's a7R 2) (*see also* page 75).
- Add flight controller, battery, charger and a transmitter/receiver.

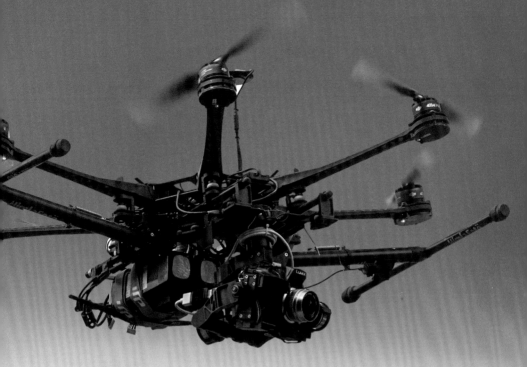

All-inclusive kits

The best way to learn how to build a drone is to buy an all-in-one kit. You won't have to source separate components. It's the most satisfactory and reliable way to build your own drone, cut costs in doing so, and you will learn a lot in the process. If it's a good set, then the components will be well balanced and the drone should perform well. You'll need to be capable of using screwdrivers, Allen keys and a soldering iron, but there will be detailed instructions for the assembly.

Pros: Great learning experience; cheaper than RTF; great potential for customization.

Cons: Better quality is more expensive than some RTF options; some all-inclusive kits don't come with everything.

Above: A fully-adapted DJI Spreading Wings 1000 with custom battery packs for longer flight times and a high-spec camera gimbal for DSLR use.

Best all-inclusive kits

Tarot FY680 Pro Hexacopter Set
– Great value for money.
– Versatility: flies anything from GoPro to DSLRs.
– Stable flight due to six rotors.

Align M690L Multicopter Airframe Super Combo
– Fast and accurate Align flight controller.
– Heavy payloads up to DSLR cameras.
– Fully customizable and upgradeable.

DIY drones
Do-it-yourself drones require a lot more time and involvement. You'll be going fully native, and will need to know how to combine a variety of different products from different manufacturers to build your ideal drone. This is not impossible at all, but make sure you seek out more specific instructions and information.

3 Your camera

With drone-camera technology getting better all the time, drones are increasingly offering sophisticated systems that deliver photography almost as good as higher-end cinema cameras. Choosing your camera can therefore be complicated, as it's intrinsically linked to how much you want to spend on the drone itself.

In this chapter we'll discuss:
- Integrated camera systems
- Add-on camera systems
- GoPro and action cameras
- Mirror-less micro two-thirds and DSLR cameras

Integrated camera systems

Before you go all-out on a lean, mean flying machine such as the DJI S1000 octocopter with a 4k camera, you want to make sure that you know what you're doing.

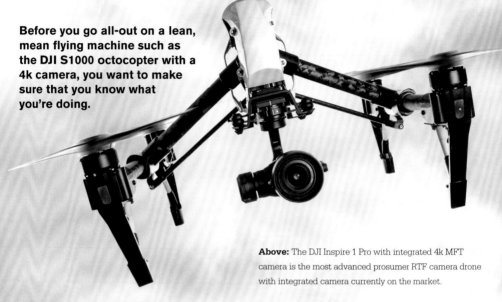

Above: The DJI Inspire 1 Pro with integrated 4k MFT camera is the most advanced prosumer RTF camera drone with integrated camera currently on the market.

The principle of flying quadcopters is pretty much the same regardless of price, so if you're new to camera drones, start small and cheap, and go from there.

Entry level

Once you move past toy drones, there'll be a simple camera on your drone that might produce 480p or VGA video quality. If you want to be serious about filming, you need a camera capable of at least 720p or HD. Anything below that will be disappointing, especially with the much higher-quality computer and TV screens we have today, so 720p for a cheap drone is pretty much a must unless you want aerial CCTV.

Affordable

As a step up from that, you can expect live-streaming video for FPV on your smartphone, or a small remote control. Controls for filming still won't be great, but often the supplied remote controls will have mounts for your smartphone or tablet, which means you'll get to use manual controls paired with your own device via a free app.

The WLtoys V666 FPV quadcopter and the Revell X-Spy are good options in this bracket, both with stabilized 720p cameras, good flight control and availability of parts. The Hubsan X4 FPV is still really a toy drone, but it offers low-level 640p video recording onto SD card and so has everything you should need to start your drone-camera adventure.

Revell X-Spy

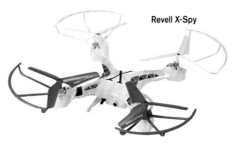

Left: The Parrot AR.Drone 2.0 can film up to 1280x720p footage with its integrated HD camera and also supports still-image capture while in flight.

Mid-range

With a little more money, you get longer flight times, higher-resolution cameras and more processing power. This means better flight controls and also better video-recording technology, and often these two go in sync.

The Parrot AR.Drone 2.0 has great build quality, a good 720p camera with a 93-degree lens and it can accommodate a USB drive on which to record video directly.

Below: The Phantom 3 Standard is a high-performance, low-cost fully integrated camera if you're on a tight budget. It's been superceded by more advanced models, but you cannot beat it for its reasonable pricing.

High-end

You only get *really* good footage with a gimbal-stabilized camera drone, and this is how DJI have conquered the drone market with great quality, built-in cameras on gimbals that record directly to USB drives or SD cards.

There is the Parrot Bepop 2 with a 14-megapixel camera and three-axis video stabilization, but you will not get better value than the DJI Phantom 3 Standard. It offers the same features of drones twice the price, featuring 2.7k video and photo quality, 720p FPV live stream and up to 25 minutes of flight time.

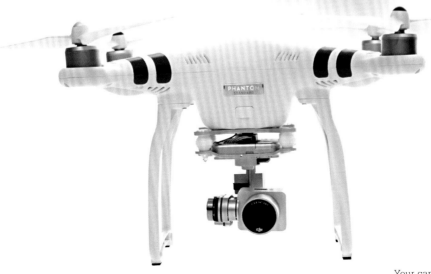

Top of the range

Currently, the two dominant players in the top-end range are DJI and Yuneec. Both have affordable 4k camera drones, and no other company currently comes close. Packed with sophisticated technology you get a solid prosumer drone that ticks all the boxes.

With the Phantom 4, DJI managed the impossible feat of improving on the Phantom 3 Professional. The only drone that comes close is the Yuneec Typhoon 4k, but it can't offer quite as much.

The DJI Phantom 4 has all the features of its predecessor, including a 4k camera with three-axis gimbal for stunning video, safety features to bring it home, fully programmable flight including follow-me function, sensors to avoid obstacles, the ability to track moving subjects and a smartphone/tablet app that lets you tap where you want it to fly. With an extended range of 5km (3.1 miles), a maximum flight time of 28 minutes and a maximum speed of 72kmh (44mph), this drone is by far the best mid-level prosumer drone currently available.

Below: The highly advanced Phantom 4 allows you to frame and capture epic aerial images and video via phone or tablet. It is able to fly intelligently via tap commands and automatically creates unbroken tracking shots in 4k.

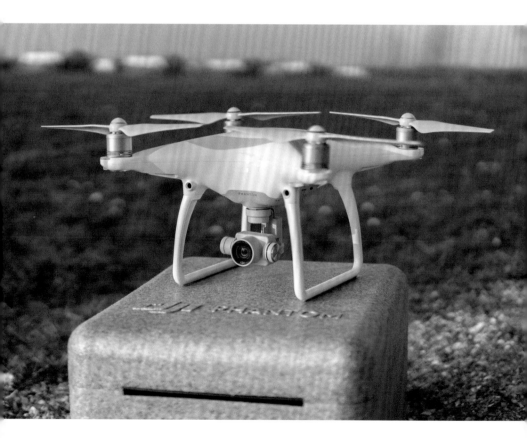

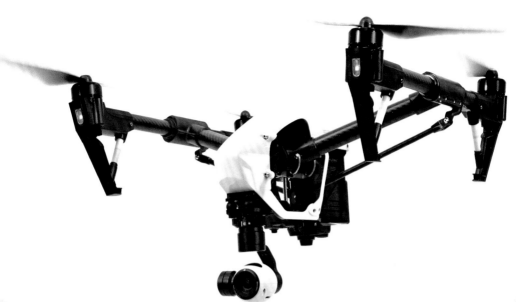

Professional

If you are looking for the highest quality in the prosumer market in RTF options, there are only a couple of drones currently available out of the box, and both are from DJI.

The RTF drone Inspire 1 V2.0 comes with professional 4k camera on a three-axis gimbal, wireless HD video transmission via Lightbridge and separate flight and camera controls. The Inspire 1 is perfect for top-quality aerial and professional shoots.

The even more professional option is the Inspire 1 Pro, which comes with a 4k micro four-thirds (MFT) camera. This is the very best RTF drone currently available. Equipped with the DJI-developed Zenmuse X5 stabilization gimbal, the 4k footage is truly groundbreaking.

Above: Even though DJI's Inspire 1 is pitched just below the Inspire 1 Pro, it is a very serious piece of technology for professional aerial filmmaking only, featuring a removable 4k camera with no fish-eye distortion and a new, upgraded Lightbridge video system.

Accessible spare parts

Drones are fragile, and you'll break a few propellers and other bits and pieces as you learn to fly them. Most drones come with a full set of spare propellers, two for each motor. This is good to be getting on with but probably not enough, so check that parts are easily available. The last thing you want is to wait for weeks every time you have to re-order a part.

Add-on camera systems

If you already have your own action camera, or you are a photographer with your own MFT camera and you're looking for the quality of image you can only get with more specific lenses, then buying a drone that supports flying your own camera could be the way to go.

If you're a seasoned photographer and a modicum of customization and research doesn't faze you, then it's a question of budget and thinking about which system you want to build on long term.

Pros of add-on camera drones

Control If you don't like the typically ultra-wide-angled lenses of integrated cameras, you can instead fly an MFT camera, a DSLR or a cinema camera – if you have a drone able to carry that kind of payload. You are able to decide on shooting mode, format, frame rate and how you record your footage.

Stabilization You can invest in a gimbal system that's perfectly tuned to your camera.

Battery life A stand-alone camera runs on its own batteries, and won't drain your drone's battery.

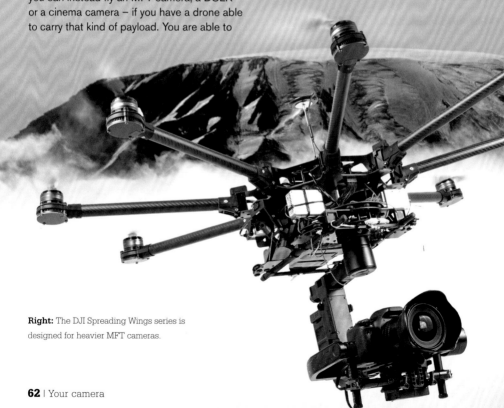

Right: The DJI Spreading Wings series is designed for heavier MFT cameras.

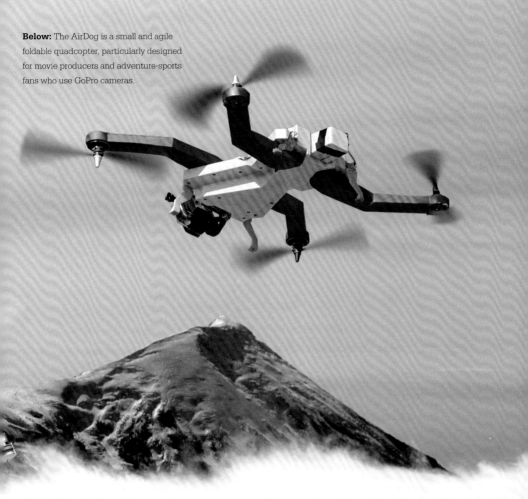

Below: The AirDog is a small and agile foldable quadcopter, particularly designed for movie producers and adventure-sports fans who use GoPro cameras.

Flexibility As it's not integrated, you can use your camera both on and off the drone. A Panasonic GH4 or an Olympus OM-D are the perfect cameras to fly on a drone, but they're equally great for small-scale, 4k filmmaking.

Cons of add-on camera drones

Additional weight Anything larger than a GoPro or Sony Action Cam will need a more powerful drone for the larger payload, larger propellers, larger gimbal and motors – which can come at a higher cost than integrated systems.

No seamless integration The fact that your camera is not integrated into your drone's system means that you probably need a secondary, dedicated control system just for your camera, and along with that a dedicated co-pilot.

Cost of purchasing A dedicated camera for your drone, as well as the gimbal system to go with it, may well set you back more than an integrated system would.

Drones with add-on camera support

The market for RTF drones with add-on camera support is by default more niche than that for integrated drones. It requires the end user to be a lot more knowledgeable about the technology involved, but even here there are a few cheaper options before you go and sell your car. Do remember, though, that these drones are priced without camera and gimbal, so you'll have to factor those into the total cost.

Affordable

In this bracket you can't expect too much from a drone that needs to support the payload of an add-on camera, so almost all drones are built to pair with a GoPro 3 or 4, as these are the most common action cameras on the market.

The Ionic Stratus Drone Quadcopter is one of the cheapest drones in this category. Built for GoPro Hero cameras, it features a six-axis gyro system, a one-key return-home function, a shock-absorption cradle head and a few fancy moves such as one-button 3D and forward rolls.

Above: The Flying 3D X8 is a good value alternative to a DJI Phantom Standard but you need to budget for extra batteries, a gimbal and camera for aerial footage.

Mid-range

Still fairly cheap, these drones, once paired with a GoPro Hero, will start to rival most DJI Phantoms – as long as you have the necessary camera to add.

The Flying 3D X8 has been on sale for over two years, so bugs in the firmware have been ironed out and build quality improved. Built for GoPros, it includes a return-home function, low-battery auto-land, 15 minutes' flying time, cheap spare batteries and a great remote with a large LCD display. All in all, it's a great alternative to a Phantom 3 Standard.

High end

Once you add your gimbal and camera, the machines in this bracket are serious drones to rival any combo drones on the market.

Three standout drones vie for your attention here, each with its own distinct identity. The BLADE 350 QX3 Quadcopter has a GoPro-ready camera mount, a 'safe' function that will keep and stabilize the drone in its position when you let go of the controls,

Above: The Ionic Stratus Drone is an affordable, highly versatile quadcopter, compatible with all GoPro Hero cameras.

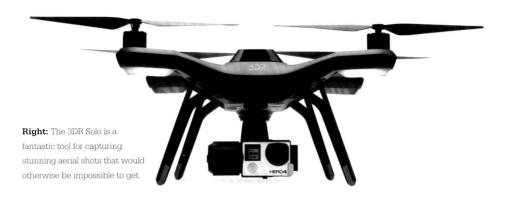

Right: The 3DR Solo is a fantastic tool for capturing stunning aerial shots that would otherwise be impossible to get.

a return-home/auto-land combo, and you can set a boundary limit so it won't stray out of range.

The 3DR Solo is more expensive than the Phantom 3 Standard and doesn't even have an integrated camera to show for it. It does have a very well-designed gimbal for a GoPro Hero, though, and it is fantastically easy to control. With filming modes such as selfie, cable cam and auto-follow, it creates footage that is almost impossible to capture if you fly manually. With cable cam, for example, you can set a starting point A position, including tilt and angle, then set a different position and angle for point B. When you press play, the Solo flies from A to B in a straight and smooth line, including panning and tilting as predetermined. For standout footage, the Solo is hard to beat, but you need to add your own GoPro.

Most expensive in this bracket is the Hexo+, aimed squarely at the aspiring action-sports filmmaker. Add a GoPro Hero and it creates stunning

4k aerial footage. As a hexocopter it has more lift and stability than most quadcopters. It also has great cinematic moves, such as a 360-degree sweep, slide past, track, auto-follow and of course the return-home function, as well as auto-land on low batteries. It is made for filmmakers who want to start filming straightaway.

Right: The Hexo+ drone works perfectly with GoPro cameras.

Top of the range

In this higher prosumer bracket you get ever-more sophisticated flight controls, but you also start looking at drones that can fly higher payloads such as a MFT or DSLR camera.

The Walkera QR X800 BNF Professional RC drone doesn't only have a long name, it also has a long list of features to justify its price tag. It can carry a range of action cameras but, more excitingly, it can lift MFT cameras and small DSLRs. Almost entirely constructed from ultra-strong, lightweight 3k carbon fibre, it has retractable legs, long flight time, auto-flight modes and waypoint flying. This is the ideal entry-level DSLR drone.

The AirDog is a well-built and well-designed follow drone that is fully autonomous from take-off to landing. Its propeller arms fold up for ultimate portability and it has a tracking device that is fast and easy to control, with a three-axis gimbal optimized for GoPro cameras. Flight modes are tailor-made for different adventure sports and include fixed follow, follow path, hover and aim, follow line and adaptive follow. The AirDog is the ultimate follow drone for adrenaline sports.

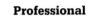

Walkera QR X800

Professional

You're now moving into professional aerial filming, with drones that can carry a range of DSLRs but still come more or less ready to fly out of the box. These are aircraft designed for photographers who want the ultimate in quality with the minimum of assembly hassle.

The DJI Spreading Wings S900 Professional Hexacopter is just that, a drone for professional aerial filming. It has six carbon-fibre arms that fold out and lock, getting the aircraft flight-ready in five minutes, and fold back in afterwards for portability. Designed for MFT cameras such as the Panasonic GH4 and the Blackmagic pocket camera, it has a short-circuit-safe power supply and low gimbal mount for a wide range of camera moves. DJI's Zenmuse camera gimbals are known for their stability, providing smooth footage in even the most difficult of conditions. The S900 is a serious piece of kit for serious aerial imagists only.

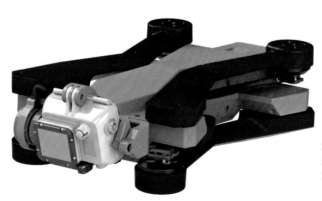

Left: Folded up, the AirDog is incredibly transportable – you can happily pack it away in your backpack.

DJI Spreading Wings S1000+

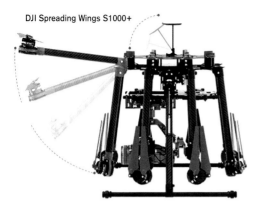

The DJI Spreading Wings S1000+ Octocopter can do everything the S900 can do, and more, for a slightly higher price tag, depending on spec.

You can fly heavy DSLR cameras, such as the 5D Mark III, smoothly with the advanced eight-rotor propulsion system, knowing your expensive camera gear is safe even in difficult flight conditions. With too many excellent features to list here, this is a serious machine for professional, broadcast-quality cinematography.

1080p, 2.7k and 4k

1080p footage is still very much the industry standard – but 4k is the future. Even though there's not much 4k material to watch on your 4k TV yet, higher resolution gives you more flexibility in the edit. You can crop in without losing quality, or create smooth pans, tilts and zooms in post.

For drone footage in particular, if you shoot in higher resolution you have a lot more pixel room to stabilize to a much higher degree. Stabilizing software crops into your full frame to smooth out erratic movement around the edges, and the larger your resolution, the more room you have to play.

Don't rush to buy a 4k camera because you want to watch it in 4k, but consider filming in 4k to help yourself in the edit to enhance your standard HD footage.

You need a more powerful edit station to be able to handle full 4k, which is four times the data size of HD, with 2.7k being about 150 per cent bigger.

Action cameras for drones

The action-camera market has become completely dominated by GoPro. There are others, such as the amazing Sony FDR-X1000V 4k, but gimbals to pair it with a drone are hard to find. This limits your choice somewhat, but there are still a couple of suitable GoPro clones.

The drones boom has caused a revolution in action-camera development, all geared towards reducing weight and improving picture quality and resolution. Nowadays 4k is almost standard, but there are other specifications you need to bear in mind, too.

Weight
If your camera is too heavy, your drone won't be able to lift it – or it might just lift it but the excessive weight will drain your drone's battery more quickly and shorten flight time. Know your drone's maximum payload capability and make sure your potential camera doesn't exceed that – including batteries.

Mounting
Ideally your mounting will be a three-axis gimbal to reduce in-flight vibration, stabilize the footage, and it also allows you to turn your camera independently of your drone's flight direction.

Price
Make sure the price of your drone and camera are not too out of step – you do not want to strap a very expensive camera to a toy drone.

GoPro Hero4 Silver ★★★★★
BEST ACTION CAMERA

Video: 4k 15fps/2.7k 30fps/1080p
60fps/720p 120fps
Photo: 12MP
Memory: Up to 64GB MicroSD
Features: Wi-fi, auto low-light mode,
night photo, burst, timelapse,
pro-tune
Battery: 45 minutes
Waterproof: With special case up to 40m
(131ft)

For the best quality and availability, look no further than GoPro cameras for the highest standard in aerial imaging. Because of their popularity you have a huge choice of gimbals available, from lowest to highest quality. Whichever drone you own, there will be a gimbal to pair it with a GoPro. The build quality is legendary, so you really can't go wrong. The biggest drawback is the 'GoPro look', due to its fish-eye lens, but if you shoot in 4k, you'll be able to remedy the distortion in the edit albeit with a slight loss of quality.

Pros: 4k resolution; gimbal
availability; build quality; LCD
touchscreen
Cons: Not the best battery life; lens
distortion; high price

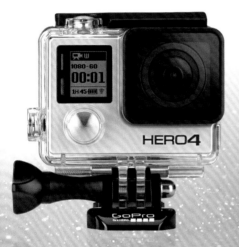

GoPro Hero4 Silver

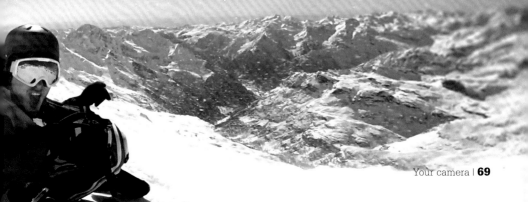

XiaoMi Yi ★★★
GOOD ENTRY LEVEL

Video: 1080p 60fps/720p
120fps/480p 240fps
Photo: 16MP
Memory: Up to 64GB MicroSD
Features: Wi-fi
Battery: Two hours
Waterproof: With special case up
to 60m (197ft)

The Xiaomi Yi is a cheap but very capable Chinese action camera. You can't shoot in 4k, but you can shoot 1080p at 60fps, which means you can slow it down to slow-motion in the edit later. Cleverly, the camera is designed to *almost* fit most GoPro mounts, so it's a great cheaper alternative. DJI's Zenmuse gimbal will need a small modification

Above: Aerial footage of dowtown Havana, Cuba, shot on RAW setting on the XiaoMi Yi.

in order to accommodate the XiaoMi Yi's very slightly larger frame. It records on a MicroSD card up to 64GB.

Pros: Low price; fits most GoPro
mounts; great image quality
Cons: Lens may need focusing; no 4k

Left: The cheaply priced XiaoMi Yi three-axis brushless BL gimbal works with most quadcopters.

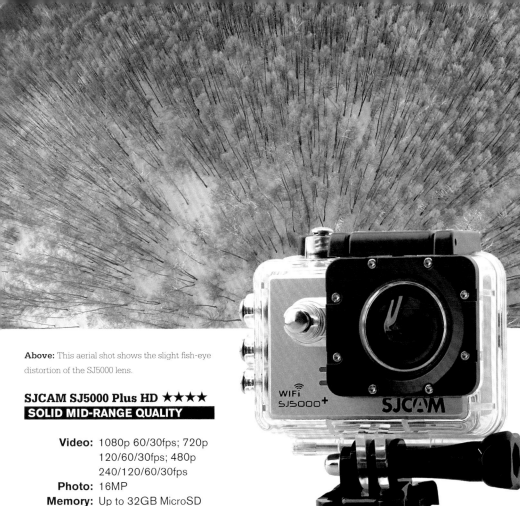

Above: This aerial shot shows the slight fish-eye distortion of the SJ5000 lens.

SJCAM SJ5000 Plus HD ★★★★
SOLID MID-RANGE QUALITY

Video:	1080p 60/30fps; 720p 120/60/30fps; 480p 240/120/60/30fps
Photo:	16MP
Memory:	Up to 32GB MicroSD
Features:	Wi-fi
Battery:	90 minutes
Waterproof:	With special case up to 30m (98ft)

The SJ5000 is a slightly more expensive version of the XiaoMi Yi. It has an LCD screen so you can instantly view what you've filmed, which is a boon not to be underestimated. This camera has a wide range of mounts and accessories on the market, including waterproof casings and drone gimbals. It records directly onto a MicroSD card up to 32GB, and the USB port allows you to download your footage and recharge the battery. You can also hook it up straight to your TV via the HDMI cable to view your footage instantly on a big screen.

Pros:	Low price; range of accessories and gimbals; great photo quality
Cons:	Only capable of recording on cards up to 32GB; sometimes suffers from motion blur

MFT cameras for drones

Micro four-thirds cameras currently present almost the holy grail of achievable, cinematic aerial imaging. They offer similar image quality and depth of field to a full-frame DSLR at less than half the weight, at affordable prices, and with a much better image quality than action cameras.

Action cameras almost always suffer from ultra-wide-angle distortion with a GoPro 'look' about it, that – let's be honest – is so 2014. So if you're really serious about aerial photography, you need to consider an MFT camera-rigged drone combo.

Panasonic Lumix GH4 ★★★★★
PROFESSIONAL ALL-ROUNDER

Sensor size: Micro four-thirds
Video: 4k (24p/25p/30p)
2.7k (30p/25p/24p)
1920x1080 (60p/60i/30p/24p)
1280x720 (60p/30p)
640x480 (30p)
1920x1080 (96p)
Photo: 16.1MP
Max still FPS: 14fps continuous
Viewfinder: EVF
Monitor: 3in tilting screen,
1,036,000 dots
Memory: 32GB, 64GB and 128GB
SD cards
Features: Most versatile lens mount
with huge range of
lenses available; 4k
Battery: Two-plus hours
Top features: Build quality,
200,000-shot
shutter life and
4k video

The same way DJI have taken the lead in the drone market, the Panasonic GH4 has become the king of MFT drone cameras. Compact and light, shooting 4k on a large variety of lenses, the camera has become legendary among pro-level filmmakers. On the drone market manufacturers have been designing drones and gimbals with the GH4 in mind. It's also a terrific stills camera, with 16.1MP images and up to 14fps continuous shooting. In addition, the 4k video lets you extract 8MP stills.

Above right: The Panasonic Lumix GH4 flown on a DJI Spreading Wings S900.

Olympus OM-D E-M10 II ★★★★
BEST IN-BUILT STABILIZER

Sensor size: Micro four-thirds
Video: 1080/60p/30p/24p
Photo: 16.1MP
Max still FPS: 8.5fps continuous
Viewfinder: EVF
Monitor: 3in tilting display, 1,037,000 dots
Memory: 32GB, 64GB and 128GB SD cards
Features: Best in-built stabilizer on the MFT market, large range of lenses; 4k timelapse
Battery: Two-plus hours
Top features: Compact and lightweight; great build quality; five-axis stabilizer

With the highly effective, Olympus-developed, five-axis stabilization system and impressive 8.5fps continuous shooting speed, 1080p HD video and very small lenses, the OM-D E-M10 II is a very compact and lightweight, yet very powerful, camera.

The GH4 drone clone

The drone manufacturer Yuneec has teamed up with Panasonic to build a drone-optimized version of the GH4. The camera, called the CGO4, features the Panasonic GH4 micro four-thirds camera sensor, a 3x optical zoom lens and can capture 16MP photos as well as 4k-resolution video. The CGO4 integrates seamlessly with the Yuneec Tornado H920, but you can also use the camera as a standalone video or stills camera.

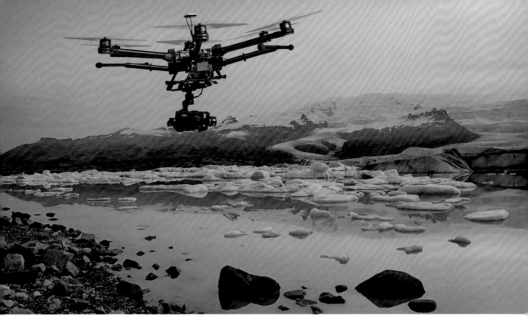

Blackmagic Pocket Cinema Camera
★★★★

HIGHEST DYNAMIC RANGE

Sensor size:	Active micro four-thirds Super 16
Video:	Full HD 1920x1080 lossless CinemaDNG RAW at 23.98, 24, 25, 29.97 and 30 fps
Photo:	8MP
Max still FPS:	14fps continuous
Viewfinder:	None
Monitor:	3.5in LCD screen
Memory:	32GB, 64GB and 128GB SD cards
Features:	13 stops of dynamic range
Battery:	50 minutes' continuous recording time
Top features:	High dynamic range film-look camera; extremely portable size

Above: A Blackmagic Pocket Cinema Camera on a DJI Spreading Wings 1000 drone.

This Super 16 camera is small enough to keep with you at all times, and one of the smallest MFT cameras to fly on a drone. The 13-stop dynamic range gives a true film-like image, lossless CinemaDNG RAW and Apple ProRes recording and the flexibility of an active micro four-thirds lens mount with a large range of lenses. This camera brings cinematic film-look shooting to the most difficult and remote places, perfect for documentaries, independent films, photo journalism and even war zones.

Sony a7R II ★★★★★

4K BROADCAST-QUALITY VIDEO

Sensor size:	42MP full frame BSI CMOS
Video:	4k lossless
Photo:	42MP
Max still FPS:	8.5fps continuous
Viewfinder:	EVF
Monitor:	3in tilting LCD display, 1,228,000 dots
Memory:	32GB, 64GB and 128GB SD cards
Features:	Five-axis SteadyShot stabilization; full-frame sensor; 4k video
Battery:	Two-plus hours
Top features:	Compact and lightweight; great build quality; five-axis stabilizer

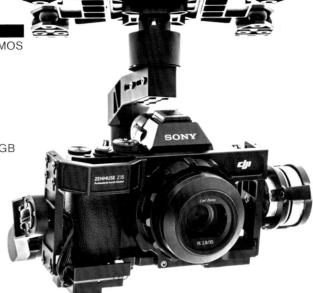

The Sony a7R II is currently the best MFT camera on the market. Only, it's not even MFT. Due to its 35mm BSI CMOS sensor, it's a mirrorless DSLR disguised as a MFT camera. It's now routinely used as a feature-film cinema camera due to its stunning results and incredible versatility. It has a weather-sealed magnesium-alloy body, the Super-35 4k helps control moiré and it has incredible shallow-depth-of-field and low-light capabilities.

DJI's Zenmuse cameras

The Zenmuse X5 and X5R both have 16MP sensors that can shoot 4k at 30fps, but the X5R can also shoot lossless 4k onto a solid-state 512GB hard drive that slots in above the gimbal.

The large sensor on both cameras can capture 13 stops of dynamic range, with an ability to shoot from ISO 100 to 25600 – on a par with the Blackmagic cine camera.

The Zenmuse cameras come with their own DJI MFT 15mm, F/1.7 prime lens, and there are currently three other MFT lenses that can be used – the Olympus M.Zuiko ED Digital 12mm F/2.0; the Panasonic 15mm G Leica DG Summilux F/1.7; and the Olympus 17mm F/1.8, a full-frame equivalent of 34mm.

If you want the best all-in-one MFT-drone package, look no further.

4 Before take-off

You're nearly at the launch site now – there's just the small matter of waiting for your drone to be delivered, and understanding what needs to happen before you can fly it. Try to focus on the issues in this chapter before you head out.

In this chapter we'll discuss:
- Unboxing your drone
- Setting up your drone, and how to charge your batteries
- The pre-flight checklist
- Calibrating your drone
- Regulation and the law

Unboxing

Before you drop your still-boxed, brand-new drone into the car and race for the nearest field, take a deep breath – and some time to unpack it properly.

Most RTF drones come with most or all of the following parts as you unbox them, but if you are unsure, always check your manual.

Instruction manual Read it. Your brand-new toy, your family and your fingers will thank you. The manual also includes a detailed list of contents, against which you can tick each item off. There will also be warnings about proper handling of propellers, batteries and such like. Heed them!

Airframe With most RTF drones, the airframe doubles up as the protective shell, holding all the electronics needed to fly the aircraft. Alternatively, more modular models have a body to which the rotor arms are attached.

Propeller pairs Typically made of either plastic or carbon fibre, these very lightweight yet rigid blades are normally not yet attached, to avoid breakage during shipping. Most drones usually come with one live and one spare set.

Motors The independently working motors are calibrated particularly for your drone and mounted on the end of the rotor arms. With a bit of technical know-how they can easily be replaced should they fail.

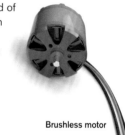

Brushless motor

Above: This kit from 3DR comes with everything you need to make a quadcopter on your own terms.

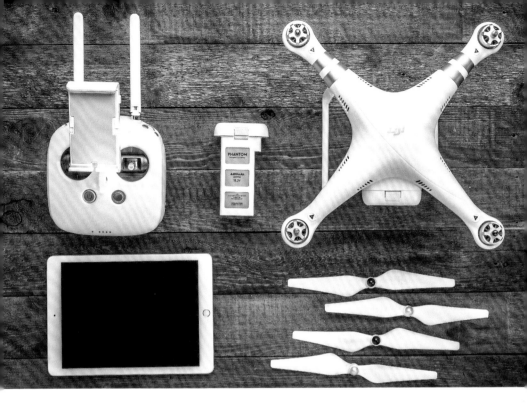

Remote controller Almost all RTF drones come with a dedicated transmitter that is paired with the drone's in-built flight controller. Some manufacturers have done away with joystick transmitters altogether, and instead require you to install an app on your smart device; but even so, the transmitter always works with two core controls. All-in-one units often come with an adjustable, front-mounted clamp to accommodate your smartphone or tablet while it is used as the control monitor.

Flight battery and charger Your drone comes with a lithium polymer (LiPo) battery (or batteries) as well as a charger. These should be packed separately, as they need to be handled with care. The volatile mix of chemicals within is highly flammable if overcharged, so the charger should have automatic shut-off at 100-per-cent charge, a storage mode and a discharge mode. If you buy replacement or additional batteries,

you need to make sure that these are fully compatible. A list of compatible batteries will be supplied with your drone or available on the manufacturer's website.

Gimbal (if not integrated) If your drone doesn't come completely RTF, it might come with the gimbal not yet attached.

MicroSD Card Most RTFs come with a MicroSD card of at least 16GB, but if you shoot in 4k this will only give you about 15 minutes of footage. It's therefore well worth investing in a 32GB or 64GB MicroSD card.

MicroSD card

Setting up

Detachable landing gear

Even though most RTF drones are advertised as ready to fly, they'll normally still need some preparation, such as charging batteries, attaching propellers or calibrating the compass before they are actually ready to fly.

Whichever drone you've purchased, it will have its own assembly instructions. Please follow them carefully. Usually you need to at least attach the propellers and battery and often you'll also need to attach a gimbal and camera, as well as landing gear.

Propellers

The props should be marked as to where they go, and which side up. Each manufacturer has a different way of doing this, so please read the instructions carefully.

Landing gear

The landing gear may or may not be part of the airframe, so again, read the instructions carefully before you attach it. The landing gear serves to protect the camera, as well as the drone itself as you land the aircraft.

Flight battery

The battery needs to be charged before you put it in. Be sure to read the instructions on how to charge your battery carefully. The chemical mix inside a LiPo battery becomes

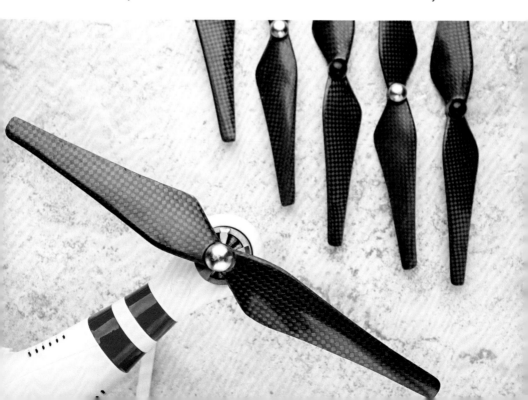

more flammable with increased charge, so it will have been shipped with less than 50-per-cent charge.

Software updates

Drone software updates frequently. There's probably been an update to your drone's software since it was shipped, so make sure to check for the latest update on the manufacturer's website. Download and install it on your computer.

Once you have completed the installation and the battery is fully charged, connect the drone, as well as the remote controller, to your computer with the supplied mini-USB cable. This may have to be done one at a time, depending on the amount of USB ports you have. If the software finds that your drone and controller are not on the most current software release, it will prompt you to update it.

Camera

There are a multitude of cameras to choose from if you haven't gone for an integrated camera package. Each add-on camera is different, and you'll need to familiarize yourself with it properly – on the ground – before attaching it.

Gimbal

Your drone might have come with a set of vibration absorbers, so make sure to follow the instructions carefully before mounting the camera. Use your RC controller to practise controlling your gimbal on the ground, so you know what you're doing before you're up in the air.

Three-axis gimbal

Charging your battery

Be careful to follow the manual religiously as you charge your battery for the first time.
– Check that your charger is set to your country's voltage system.
– Make sure that you know what the indicators on your charger mean, so that you know when your battery is fully charged or if there is a problem with charging.
– If your battery has power leads attached, make sure they never touch in order not to cause a short circuit.
– If you feel something is not right, unplug the charger before you do anything else.

Opposite: The propellers of the DJI Phantom series are self-tightening and easily replaceable.

Pre-flight checks

Each drone requires its own series of checks, but there are some procedures that you should have on any pre-flight checklist, regardless of which drone you're flying. This will help keep your drone and gear safe.

In addition to cross-checking your drone, you need to know the location where you're intending to fly, so that you don't lose your drone or fall foul of the law.

Check your drone
- Is there any previous damage?
- Are the batteries charged?
- Do you have spare batteries?
- Is your smartphone or tablet fully charged?
- Is your camera battery charged (if separate camera)?
- Is your SD card empty and formatted?

Above/below: Make sure your propellers are tightened properly, and that you're using a battery that has recently been charged.

Check your location
- Is it clear of people and habitation?
- Is it clear of power lines, buildings and trees?
- Is it a no-fly zone or airport?
- Are there any government buildings nearby?
- Are there any busy roads or train tracks?
- Do you have a fully charged phone?
- Do you have a first-aid kit?

Above: A large treeless area, devoid of people and animals and away from urban habitation, is an ideal launch spot.

Pre-flight checks

- Put the drone in a level take-off position.
- Turn on the camera.
- Check that the transmitter controls communicate correctly.
- Put the transmitter controls to neutral.
- Put the throttle to neutral.
- Turn on the transmitter.
- Connect the drone battery.
- Power up the drone.
- Double-check for passers-by, children and animals*.
- Start the flight timer.
- Stand clear.
- Arm the flight controller.
- Increase the throttle carefully.
- If everything's okay, lift up and hover.
- Check for the stability of the motors and props.
- If everything looks okay, start your flight.

* Do not launch your drone if there are horses and/or riders nearby. Horses can spook dramatically and you'll risk the horse and rider's safety. Wait until they're a safe distance away.

Above: An upturned plastic crate is a great, level platform to perform pre-flight checks on.

Above: Put both controls to neutral before you turn on the transmitter and connect the drone battery.

Calibrating your compass

It's important to calibrate your compass properly. Do this every time you fly, especially if you're flying in a new location. It will help to keep your drone safe.

1. Stay away from metal structures, large concrete buildings or phone masts as these will interfere with calibration.
2. Switch on the controller.
3. Power up your drone.
4. With the controller, swich your compass to 'calibrate'. This might differ slightly from brand to brand. The lights on your controller and drone will light up in yellow. Some brands may use different colours.
5. Keeping your drone level, spin it until one of the two lights turns green (Fig 1).

Fig 1

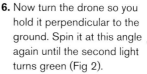

Fig 2

6. Now turn the drone so you hold it perpendicular to the ground. Spin it at this angle again until the second light turns green (Fig 2).
7. The lights will flash red if there's been an error, in which case repeat the last three steps again until you succeed.

Rules, regulations and the law

When flying a drone, you need to know about rules and regulations. If you break the law, even inadvertently, you could be fined or even jailed. It's not only about the danger of increasing low-level air traffic, there's also the risk your drone presents to people and air traffic, and the potential of breaking privacy laws.

If you own a drone that weighs anything from zero to 150kg (332lb) when it takes off, you fall under the regulation of your aviation authority. In Europe, this is the European Aviation Safety Authority (EASA), in the UK it is the Civil Aviation Authority (CAA) and in the USA it is the Federal Aviation Authority (FAA).

The regulations vary slightly from country to country, but the following rules are common throughout. Please make sure to read them and adhere to them.

You are responsible for your flight

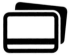
You are legally responsible for every flight, and anything that might happen as a result. Therefore, failure to comply with the law could lead to a criminal prosecution.

Private or commercial?

If you pursue aerial imaging professionally, i.e. make money from it, you'll have to register with your aviation authority. But even as a hobbyist you're bound by the regulations below.

Stay below 125m (400ft)

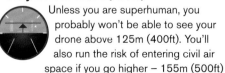
Unless you are superhuman, you probably won't be able to see your drone above 125m (400ft). You'll also run the risk of entering civil air space if you go higher – 155m (500ft) is the lower limit at which civil aviation flies.

Stay within 500m (1,640ft) and line of sight (LOS)

The maximum distance allowed from the operator is 500m (1,640ft), any further and you won't be able to see your aircraft. You must keep your drone in sight at all times. If you intend to fly FPV out of sight, you need to obtain clearance from the authorities first, unless you're in an uninhabited area.

The 50m (165ft) rule

When you take off, you must be 50m (165ft) away from people, vehicles, buildings, structures and protected monuments. Your drone must not be flown within 50m (165ft) of any structure, vehicle or person that is not part of your project and fully briefed. Your drone cannot be flown near government buildings or heritage sites.

The 150m (490ft) rule

You must not fly within 150m (490ft) of any congested area, such as a village, town or city. You must not fly directly over congested areas, people or roads. You must also not fly within 150m (490ft) of any crowd of people, such as concerts and sports events.

Don't fly at night

You must not fly at night in urban or crowded areas without special permission from your authority.

No-fly zones

 Never fly a drone near aircraft, helicopters, airports and airfields. You must keep a distance of at least 5km (3 miles). It is a serious criminal offence to endanger the safety of an aircraft in flight.

Do not fly near or over sensitive infrastructure or property such as power stations, water-treatment facilities, correctional facilities, heavily travelled roads or government facilities, and never, ever go over military areas.

Privacy laws

 Think about what you do with any images you obtain, as you may break privacy laws. Details vary with each country.

National parks and wildlife reserves

 As of 2015, the flying of drones has been banned from all national parks in the USA, most wildlife reserves in South Africa, all National Trust-managed land and nature reserves as well as most listed heritage sites in the UK and Europe. This is due to serious concerns about the negative impact that drones may have in these protected spaces.

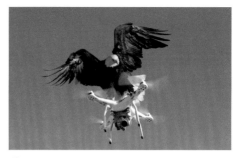

Above: A trained bald eagle grabs a drone mid-flight.

Anti-drone systems

Anti-drone systems are being rapidly developed all over the world to counteract the threat that drones can potentially pose to the authorities and the general public.

Dutch police have joined forces with a raptor-training firm to trial domestically trained bald eagles to bring down drones. They have also developed a UAV that can shoot a net at the offending drone to bring it down.

In the US, radio-frequency disruption has been tested successfully and in the UK, airport authorities are considering a system called Skywall. This involves a capsule containing a net being fired at the drone. It opens above the aircraft to release the net, which in turn brings down the drone.

Stay safe

Be aware of the damage your drone can cause if you make a mistake.

Risks

- You can cause a fire by not being present during the charging process.
- You can cause car accidents by letting your drone stray.
- You can cut off a finger with the props.
- You can even cause a plane to crash.
- Your drone can drop out of the sky like a stone and cause severe injuries.

Safety measures

- Always charge your batteries correctly. Don't overcharge, and be present when you charge them.
- Learn to fly your drone manually before you make autopilot a habit.
- Join a local flying club to learn new skills and keep within the law.
- Always keep your distance from people, built-up areas, crowds and busy roads.
- Do not fly in adverse weather conditions such as in high winds or reduced visibility.
- Do not fly under the influence of alcohol or drugs.
- Always read the regulations in your own country.

5 Learning to fly

This is where the fun really begins. If you've skipped everything until this section, go back and at least read the rules and regulations, and how to stay safe – and don't show your face here until you've done so.

In this chapter we'll discuss:
- All the new terms and definitions
- How to control your drone
- Take-off and landing
- Advanced GPS technology
- Vision positioning systems

Terms and definitions

Every activity has its own language, definitions and terms. With drone flying, a lot of it is derived from civil aviation, as well as from the days of RC modelling.

Before we sit down in flight school, you'd better brush up on your drone language skills.

General terms
Line of sight (LOS) You're able to see your drone throughout the flight.
First-person view (FPV) Instead of, or as well as, seeing your drone in line of sight, you can see what the drone camera sees on your LCD monitor.

Transmitter controls
Transmitter control sticks are always set to the same factory settings – the left stick is used for throttle and yaw, while the right stick is used for pitch and roll. Your drone's manual will tell you how to switch modes if needed.

Right stick
Pitch By pushing the right stick forwards or backwards, your drone will pitch and move forward, or pitch and move backwards.
Roll Pushing the right stick right or left will tilt the drone left or right, thus moving it left or right.

Left stick
Throttle Push the left stick forward to engage and up the throttle, to create lift. Push it backwards to disengage the throttle, and bring down the drone.

Yaw Pushing the left stick left will make the drone rotate (yaw) left and pushing it to the right will make it yaw right. This points and moves the drone in a different direction.

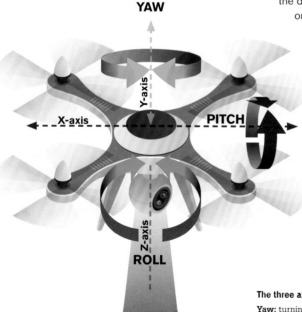

The three axes of flight movement
Yaw: turning sideways on the Y-axis.
Pitch: pitching forwards and backwards on the X-axis.
Roll: banking side to side on the Z-axis.

Control

Trim If your drone pulls in one direction in calm conditions (or indoors) even when your controller is in a centred position, it needs trimming (calibrating) before you fly it (*see box, page 93*).

Rudder If you join a local flying club, you might hear this term bandied around. It stems from the days of RC modelling and is a different word for the yaw control of the left stick.

Aileron Controlling the 'roll' movement (left and right) with your right stick.

Elevator Controlling the 'pitch' movement (forwards and backwards) with your right stick.

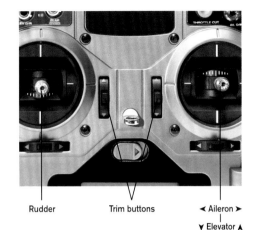

Rudder Trim buttons ◄ Aileron ►
 ▼ Elevator ▲

Manoeuvring

Bank turn Steady left or right turn, by banking left or right, to fly in a steady half-circle.

Hovering Keeping your drone in the same position (X and Y axis) whilst airborne.

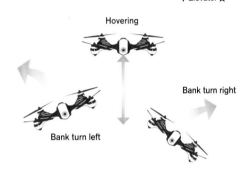

Hovering

Bank turn right

Bank turn left

Flight modes

Manual Completely manual mode. Any movement you initiate (roll, pitch and yaw) will only stop when you counteract it. If you let go of your stick it won't auto-level the drone.

Attitude or auto-level Once the sticks are centred, the copter will level itself out. You're still flying manually, but the drone helps you compensate each time. If you let go of the sticks, the drone continues in the same direction it was heading.

GPS hold If you let go of the sticks, the drone stops and holds its position.

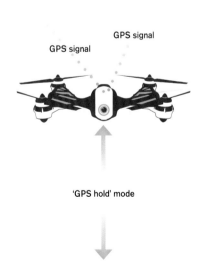

GPS signal

GPS signal

'GPS hold' mode

Above: Phantom 3 flight modes.

How to control your drone

Understanding how the multiple rotors on your drone interact, how completely different this is from winged flight and how your RC-transmitter controls actually work is the first step when learning to fly your drone.

E ach control has several functions, those in turn interact with the other control's functions and the sum total makes up the experience of flight. The harder you push either of the controls, the stronger the drone reacts. When you start practising, be gentle and careful until you get a feel for it.

Main controls

The main controls for your drone are roll, pitch, yaw and throttle.

Roll Rolling (or leaning) left or right moves your drone left or right. Push the right stick to the left to move left, and to the right to move right. If you push hard, the drone will literally 'roll'.

Pitch To gain forwards or backwards speed, you pitch the drone forwards or backwards.

Yaw This movement is probably least like that of a fixed-wing aircraft. Yaw rotates the copter horizontally clockwise or anti-clockwise. Push your left stick to the left or right to yaw.

Throttle This controls the acceleration of the propellers, which creates the 'lift' for the aircraft. The faster the props spin, the more lift you'll get. Push the left stick forwards to engage the throttle, and pull in backwards to disengage. Remember not to completely disengage – you'll lose the lift and the drone will plummet to the ground.

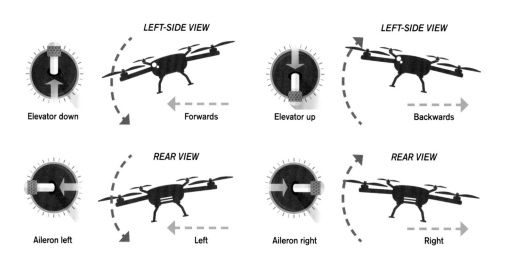

LEFT-SIDE VIEW

Elevator down — Forwards

LEFT-SIDE VIEW

Elevator up — Backwards

REAR VIEW

Aileron left — Left

REAR VIEW

Aileron right — Right

Flight simulator

Before you fly your drone, check if there is a flight simulator available for your specific make. The Phantom 3 flight simulator, P3-Simulator, runs on your flight controller and you can practise flying your drone with your actual controls without risking the drone and your safety.

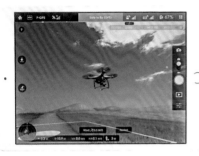

Above: There's a lot to be gained by practising your flight with ultra-real simulators such as the P3 that can even create adverse weather conditions.

Auto-flight

The trend for fully automatic flight has resulted in some jaw-dropping performances, especially with DJI's Phantom 4 and announced Phantom 5. You can now fly your drone by just tapping on the touchscreen where you want to go, and the drone will fly there and avoid all obstacles along the way. When you want it to come back, or the battery is running low, the drone will come back to you on its own and land at your feet.

Choose the right place

Be careful where you launch until you really know what you're doing.
– Don't fly in enclosed spaces.
– Find an open field, or a large park. Grass helps to minimize the damage on impact in case of a crash.
– Stay away from people and stay away from animals.
– Avoid windy conditions, especially when filming.

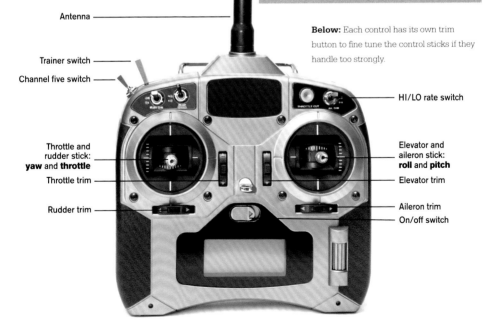

Below: Each control has its own trim button to fine tune the control sticks if they handle too strongly.

Antenna

Trainer switch

Channel five switch

HI/LO rate switch

Throttle and rudder stick: **yaw** and **throttle**

Throttle trim

Rudder trim

Elevator and aileron stick: **roll** and **pitch**

Elevator trim

Aileron trim

On/off switch

Take-off and landing

Before take-off, you need to read 'Rules, regulations and the law' on page 84. Pay attention to the information on how to stay safe and go over the pre-flight check-list on pages 82–83 again.

Before flying, make sure to read your drone's manual. Then follow these steps.

1. Prepare your camera
Switch on your camera and set it to your intended shooting mode. Remove the lens cap. If you have one, remove the gimbal holder (the bracket that protects your gimbal and camera during transport). If the camera is integrated, as with DJI's Phantom 4, all you need to do is remove the lens cap and set the shooting mode in your mobile app.

2. Launch position
Find a flat and ideally dust- and gravel-free place. Make sure it is wide enough to land the drone again. If you're using the return-to-home (RTH) function, your drone will come back to land in the same place. Place your drone in the centre of your launch area, facing away from you.

3. Connect your battery
Before you connect the battery, make sure that the throttle is pulled all the way back to zero. Your drone shouldn't fire up the engines just because you've connected a fully charged battery, but if it does, the zeroed throttle helps you avoid injury.

Below: Make sure the propellers are tightened and balanced.

4. Calibrate the IMU, gyroscopes and compass

Calibrate the compass before every new flight. The compass is very sensitive to electromagnetic interference, which can produce abnormal compass data and lead to poor flight performance or flight failure. It is also important to calibrate the internal measurement unit (IMU) and gyroscopes (*see* box, right).

For the compass, make sure you're well away from magnetic disturbances such as power lines or loudspeakers. Within your app, select 'compass' and then 'calibrate'.

5. Set the home GPS co-ordinates

Calibrating the compass, during which the flight controller also locks on to all available satellites, will normally set the home GPS co-ordinates. With some drones, though, there might be a separate GPS lock function.

6. Start the motors

With a lot of drones, a combination stick command (CSC) is used to start the motors. With the Phantom 4, you push both sticks to the bottom inner or outer corners to start the motors. Once the motors have started spinning, release both sticks simultaneously. Now the drone is armed and ready to fly. With other drones, this procedure might be slightly different, but once your drone is ready to fly, do not touch it any longer, as it might confuse the electronics if it is moved. Stay 3m (10ft) away.

If your drone is not flying as it should, or it pulls in one direction, it needs trimming. The two main causes for 'drift' are wind and unadjusted gyros.

Calibrate the IMU and gyroscopes

The internal measurement unit (IMU) measures acceleration, pitch, roll, yaw and throttle using micro gyroscopes. Only calibrate your IMU if calibrating your compass has not eliminated the problem. Normally, the IMU should only be calibrated after a firmware update or a transport.

Your drone does not automatically know what 'level' is, so it needs to be set, or reset, in order to clear up any accumulated data error. The calibration process resets the gyroscope and accelerometer data to tell the aircraft when it is perfectly level and not moving.

The aircraft should have been switched off for at least ten minutes and should ideally be in a cool location such as an air-conditioned room or in a cool climate. The drone should be placed somewhere stable and, ideally, a spirit level placed across from motor to motor to check for perfect level before you calibrate.

7. Take-off

Push the throttle up slowly to take off or use auto take-off. After take-off, hover your drone at a low altitude for a minute to make sure it doesn't drift and performs normally. If it does drift, bring it back down and calibrate it (*see* box, above). Carefully attempt a couple of directional moves to make sure that your drone is fully under your control.

8. Landing

To land, hover over a level surface and gently pull down on the throttle to descend. You'll soon get used to how quickly or slowly your drone reacts to the controls. When landing, be careful not to pull the throttle all the way back before you're at most 30cm (1ft) off the ground.

Advanced drone GPS technology

Drone waypoint GPS navigation is far more advanced than in a handheld GPS device. It has to fly the drone, keep it very stable in the air, fly to the configured waypoints at the correct altitude and speed, and then come back to its starting point.

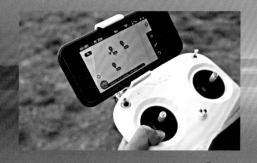

Flying a camera drone with GPS co-ordinates on a programmed course means that you don't have to worry about flying your drone and can instead concentrate on the camera. At any stage during the waypoint flight, you can take back control of the drone and either change its course or bring it home.

Left: Draw the course on your map and the waypoints will be added automatically.

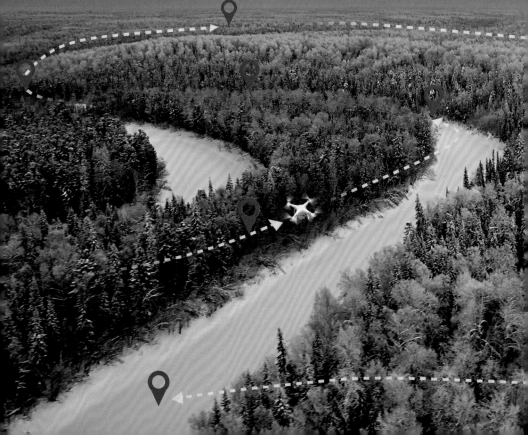

Setting waypoints

Using the 'ground station' feature in the app, users can drag up to sixteen pins onto a map of their current location, each of which indicates a GPS waypoint for the copter to hit on its flight. It's also possible to set the altitude for each of those waypoints, along with the aircraft's rate of speed upon reaching them.

Once done, hit the 'go' button, which will launch the drone autonomously to carry out its mission. Now you're free to control the gimbal, which is a whole job in itself.

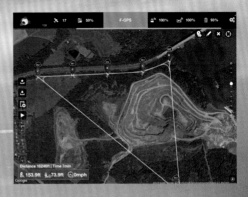

Below: When you set waypoints with advanced GPS technology, you don't only set your GPS co-ordinates for the location, but you also specify altitude and speed.

Above: Given the long range and battery life of the Phantom 4, you can plot quite an elaborate flight course and still get the drone home safely.

Auto take-off and landing

Auto take-off

Use auto take-off only if your drone has acquired enough satellites for sufficient GPS lock. It will indicate if this is the case in its app.

1. Complete all the steps on the pre-flight checklist.
2. Once your drone has sufficient GPS lock and it indicates that it's safe to fly, tap on auto take-off and take off.
3. Depending on the app, the aircraft will hover at around 3m (9ft) off the ground, awaiting further instructions from you.
4. With the Phantom 4, the aircraft status indicator will blink rapidly if it is using the vision positioning system (*see* page 96) instead of GPS. In this case, it is recommended to wait until there is sufficient GPS lock before using the auto take-off feature.

Auto landing

Use auto landing only if your drone is flying on enough satellites for sufficient GPS lock. It will indicate if this is the case in its app. With the Phantom 4, the aircraft status indicators will be blinking green.

1. Ensure the aircraft is in GPS or P-mode.
2. Check the landing area before beginning to land. Then follow the on-screen instructions in your app.

Vision positioning system (VPS)

Until recently it wasn't possible to achieve precision hovering without GPS, but some companies have now added vision-positioning systems to their drones.

French company Parrot may have been the first to employ VPS, but China-based DJI have since taken the lead, adding it first to their high-end Inspire 1 drone, and then rolling it out across their Phantom range.

Inspired by the way bats navigate through darkness, VPS uses ultrasound sensors as well as a monocular camera to read the ground below and help the aircraft to maintain its position.

DJI's vision positioning system

DJI built their VPS from the ground up, adapted for large-scale indoor aerial filming. The system combines visual data and sonar waves in a single unit, detecting both variance in patterns on the ground and current altitude. With this information, the drone can hover in place or move around.

All the visual and sonic data is handled by a dedicated central processing unit (CPU)

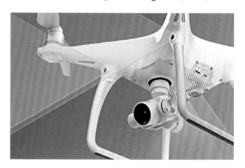

Above/below: Phantom 4's front- and down-facing sensors that make up its vision positioning system.

Above: Phantom 4's obstacle avoidance system.

Below: Ultrasonic emitters and sensors map the ground below.

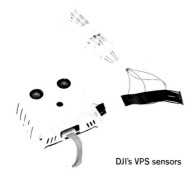

DJI's VPS sensors

chip, sophisticated enough to distinguish between objects and ground patterns. The CPU processes data in real time while feeding it through to the flight controller, which in turn communicates with the entire aircraft.

A word of caution

VPS definitely has its limits, and can only function accurately if you stick within those limits. Keep the sensors clean at all times, otherwise it won't be able to 'see' or 'hear' properly.

Never fly it around animals. The VPS sonar sensor emits high-frequency sounds that are audible to animals such as dogs, bats, birds and rodents, and it will be extremely loud, disorientating and frightening to them.

Right: Reading the ground below and ahead, Phantom 4's VPS allows the drone to fly without GPS.

6 Preparing the shoot

Aerial photography is hard to control, so every bit of planning you've put in will help you during the shoot. Be clear about what you're hoping to achieve, and to what purpose. If it's just a bit of fun, relax. If it's professional, you should try and prepare each part of the shoot that is under your control as far as you are able.

In this chapter we'll discuss:
- How to prepare for the location, the weather and the shoot
- What to pack for your drone
- What to pack as filming gear
- Shot lists
- Your essential tool kit
- The best camera settings for aerial photography
- Exposure, ISO and white balance
- Resolution, frame rates and aspect ratio

Pack list and preparation

As with most things in life, preparation is key. Whatever you are shooting, do as much work beforehand as you can. This will greatly reduce the stress on the day, especially if you have created a shot list to work from.

Pack list

Depending on your subject and location, this pack list of essentials can be used as is or expanded upon if need be.

Drone pack:
- Your drone
- Spare props
- Two charged batteries (one spare)
- Charger
- ND filters
- Controller
- iPad/tablet
- Smartphone as a backup
- Printout of the local rules and regulations
- GoPro or similar (in case your drone doesn't have an integrated camera)
- SD cards
- Tool kit (*see* box, opposite)
- Lens-cleaning kit

B-roll pack:
- MFT or DSLR camera
- Tripod
- Sound-recording eqipment

(*see also* page 119)

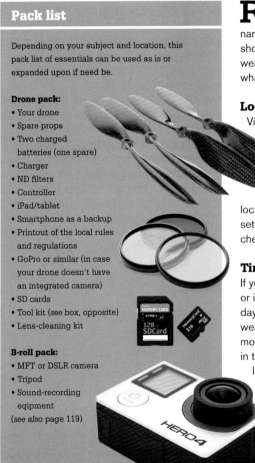

R emember that if you are attempting to capture aerial footage to cut into a bigger narrative that you or somebody else has already shot, you need to make sure that the light, the weather and the time of day all match up with what's already been shot.

Location

Visit the location prior to the shoot, walk around it and get a feel for it. Try to be there at the same time of day as is planned for the shoot, to see the likely conditions. Test your drone, get a GPS lock, calibrate it to the location and experiment with your camera settings. Go through the pre-flight location checklist on page 82 for more tips.

Timing and weather

If your shoot is not part of a bigger narrative, or if you're in a position to decide what time of day you want to shoot, make it early. Wind and weather conditions are often better in the early mornings, and the quality of light is much better in the early sun. Evening light can also be lovely, but remember that the approaching darkness might mean that you run out of time.

The importance of shot lists

Every film or photo essay can be planned out to some degree. What needs to happen? How do you want to capture it? Filming a skiing competition, for example, you already know that there will

be skiing, you know the location and who will take part, and you know which one of the competitors you want to film. With that in mind, you can already make a list of everything you're trying to cover.

If you're filming consecutive competitors to cut together later, it is important that your shots match up somehow – a slow-motion shot, a close-up, a wide shot, a jump, etc. This is the way to create a sense of place, as your audience will start to recognize each bend and jump. Also, if the shots don't match, it will be very hard to cut together later.

Lens-cleaning kit

Your lens-cleaning kit should contain:
• A soft-bristled lens-cleaning brush
• Lens-cleaning solution
• A lens-cleaning cloth
1. Use the brush to carefully remove dust and dirt.
2. Apply a few drops of cleaning solution to the cleaning cloth.
3. Using a circular motion, gently work it from the centre outwards to clean the lens.

Tool box

Use a sealable, waterproof plastic box
• Hex driver set (metric)
• Micro-screwdriver set
• Screwdriver (flat and cross-head)
• Scissors
• Electrical tape
• Double-sided sticky tape
• Voltmeter (multi-meter) to check batteries, etc.
• LiPo battery checker
• Glue set (foam safe, super glue, CA glue)
• Goop
• Snips
• Wirestrippers
• Needle-nose pliers
• Blue threadlock
• 12V cigarette lighter converter to charge batteries
• Stanley knife
• Sharpie (to label batteries, SD cards, etc.)
• Liquid electrical tape
• Variety of zip ties
• Two LiPo-safe battery bags (one for charged batteries, one for discharged batteries)
• Duct tape
• Roll of velcro

At home:
• Soldering iron
• Rosin-core solder
• Micro drill

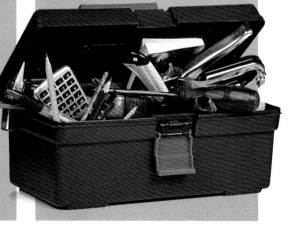

Camera settings for aerial photography

As with landscape photography, the biggest challenge with aerial photography is retaining a good dynamic range. The sky is very bright compared to a much darker ground, which means that it's difficult to balance highlights with dark shadows. This means that you need to work out your camera settings before you start shooting.

The integrated DJI Phantom camera uses the same 1/2.3-inch CMOS 12MP sensor as the GoPro Heroes 3, 4 and 5. It's a decent sensor, but you'll need to get the settings just right in order to get the most flexibility in post-production.

Camera settings

These settings are based around the DJI Phantom 4 camera and GoPro Heroes 3, 4 and 5, but you can easily adapt them for larger MFTs or DSLRs – the principle remains the same. On the Phantom 4, you change the camera settings through the DJI app.

Wireless If your camera supports wireless, turn it off. It needlessly drains the battery and can interfere with the drone controls.

Resolution 4k gives you the highest resolution and therefore the most pixels to play with to stabilize footage in post, but due to the high amount of data, you can't shoot in slow-motion. 4k needs a lot more data storage space and processing power in post.

Below: The camera settings panel in the DJI Phantom app lets you adjust the settings depending on the conditions you're filming in.

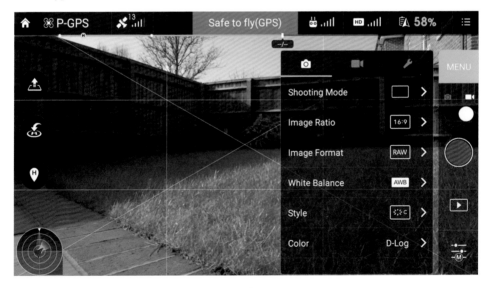

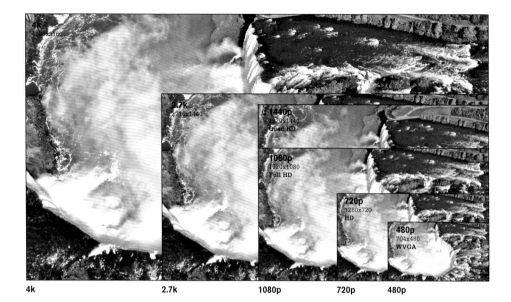

| 4k | 2.7k | 1080p | 720p | 480p |

2.7k is best for action shots and some slow-motion. It is the most flexible option, as even after stabilizing and de-fisheyeing (where you will lose pixels), it still has the best quality.

Below: 4k Phantom 4 footage shot on ISO400.

1080p (HD) is enough for any TV playback, and you have the option to shoot at much higher frame rates for great slow-motion (60fps or 120fps). In contrast to 4k, you have less 'wiggle' room or pixels available to steady the footage in post.

Advanced Settings

Protune	ON
White Balance	CAMERA RAW >
Color	FLAT >
ISO Limit	1600 >
Sharpness	MEDIUM >
Exposure Compensation	-0.5
Reset to Default	

Above: If you have the possibility, always shoot in RAW. This will give you so much more image quality to play with in post-production.

Frame rate 24fps (literally 23.976fps). You need to transcode everything to 24fps in the end, as that is the frame rate for playback. Shooting in 24fps also gives you a beautiful, cinematic look.

Aspect ratio 16:9 or 17:9 for video (wide or super wide for GoPro), but if you're just shooting stills, choose 4:3 to use the full sensor.

RAW/Protune Shoot in RAW, or on GoPro, turn on Protune. You'll get a larger, more neutral dynamic range, which will help you a lot during the colour grade.

White balance (WB) It's important to either set the white balance correctly or to shoot in RAW and correct colour in post.

GoPro Hero4 Black footage shot with:
ProTune
White balance: Native (RAW)
Colour: Flat

Final Cut Pro X Colorized:
Exposure and saturation gain
Contrast: +15
Hue and saturation: -2

GoPro uses 'Cam Raw' or 'Native', which is GoPro's version of RAW, and the Phantom offers 'LOG' instead. Don't use any GoPro colour presets! For more information consult the table, right.

ISO 400 or below. The higher the ISO, the more light you get and the faster your shutter speed, which results in grainier and more jerky footage and the dreaded 'jello' effect. A lower ISO means lower shutter speed and less grain.

Sharpness LOW. This will make it more film-like and less like a '90s video.

Lens setting (GoPro) Medium. Wide and ultra-wide need too much distortion correction in post.

Filter Use a neutral density (ND) filter and/or polarizer. These counteract excessively bright conditions and give you the option to shoot with lower shutter speeds, which will make everything look a lot more cinematic.

White balance

If you don't have the option to shoot RAW on your camera, use this table to set your WB.

Colour temperature	Light source
1,000–2,000K	Candlelight
2,500–3,500K	Tungsten bulb (household variety)
3,000–4,000K	Sunrise/sunset (clear sky)
4,000–5,000K	Fluorescent lights
5,000–5,500K	Electronic flash
5,000–6,500K	Daylight with clear sky (sun overhead)
6,500–8,000K	Moderately overcast sky
9,000–10,000K	Shade or heavily overcast sky

Best Phantom 4 settings

These settings will give the highest quality and flexibility in post-production. However, you will have to colour grade, as any professional filmmaker would.

General settings (in the camera operation bar)
Resolution – 4k or UDH at 24fps
Video format – mov
Video standard – NTSC
White balance – Custom: 5,100K for daylight
Style – Custom: sharpness -2; contrast -2;
Saturation -2
Colour – D-log for best dynamic range

Other settings (wrench icon)
Histogram – Enable for contrast control
Video caption – Disabled
Over-exposure warning – Off (because you have Histogram)
3D noise reduction – Day = off; night = on
Grid – Grid lines (to control the gimbal alignment)
Anti-flicker – Auto
File index mode – Continuous (best for filing and editing)

Exposure
Auto/M – M (manual)
ISO – 100 (as low as possible)
Shutter – 2x the frame rate = 50

Below: If it's too bright, use an ND filter. Get a variety of Phantom 3 filters: ND8, ND16 and ND32 are very useful.

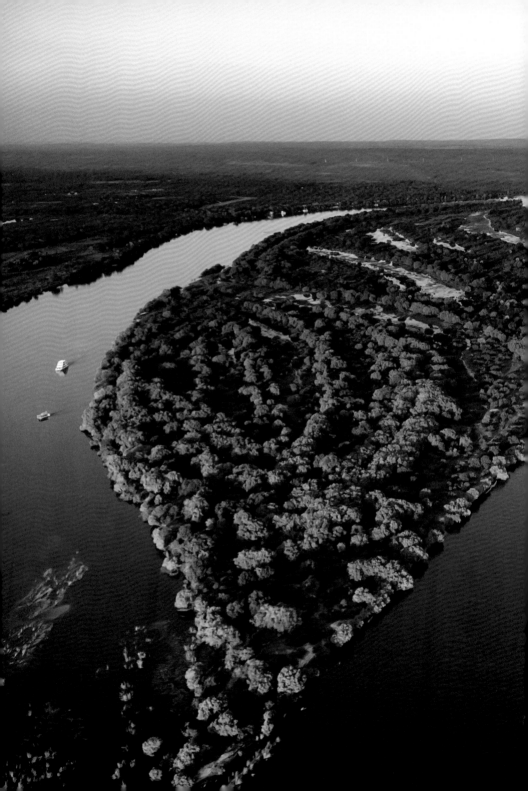

7 Filming

This is what you've been waiting for. You've learned how to fly your drone, you've practised your aerial acrobatics, you've fine-tuned your gear list and you've tested out your camera and decided on the best settings and filter combinations. Now let's slot in a fresh SD card, charge the batteries and take to the air. Once you have worked through this chapter, shot by shot and page by page, you'll have all the tools you need to set you on your way to becoming a professional aerial imagist.

In this chapter we'll discuss:
- Drone camera techniques
- How to develop your style
- Where to find inspiration
- Hollywood aerial cinematography
- Sixteen classic camera moves adapted for drone cinematography
- The importance of ground-level B-roll

Drone camera techniques

Aerial shots work best when they put sequences shot on the ground into a bigger perspective, or when they transport the audience from one story strand to another. There are distinct techniques – evolved over decades in everything from Hollywood films to BBC nature programmes – that you can harness for your own work.

When you're planning for a day out filming, knowing what you're going to film but with only a vague idea of what's actually going to happen, you can still plan how you're going to film it so that it cuts in seamlessly with your bigger narrative.

Style

Whether you're planning to float balloon-like over dreamy landscapes, get low, fast and furious with a screeching car chase or track animal migration from the air, the first thing you need to do is decide what style will fit with the rest of your film. What kind of movement is prevalent in your ground-shot footage? What kind of aerial movement will complement that, and cut together nicely? Write down a list of ideas, and even sketch out movements on paper to get a sense of what style you'd like to go with.

Choreography

If you're shooting something scripted, even something like an adventure documentary about a couple of daredevil skiers or climbers, there are things that you can plan carefully and discuss with your subjects so that once they move off, everyone knows what they are

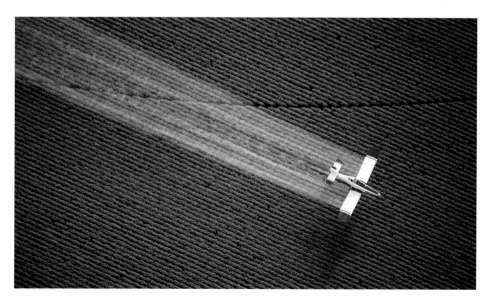

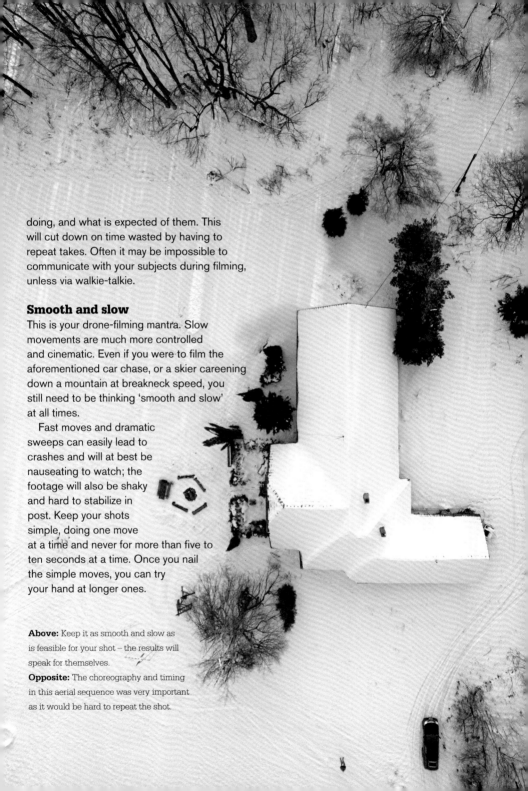

doing, and what is expected of them. This will cut down on time wasted by having to repeat takes. Often it may be impossible to communicate with your subjects during filming, unless via walkie-talkie.

Smooth and slow

This is your drone-filming mantra. Slow movements are much more controlled and cinematic. Even if you were to film the aforementioned car chase, or a skier careening down a mountain at breakneck speed, you still need to be thinking 'smooth and slow' at all times.

Fast moves and dramatic sweeps can easily lead to crashes and will at best be nauseating to watch; the footage will also be shaky and hard to stabilize in post. Keep your shots simple, doing one move at a time and never for more than five to ten seconds at a time. Once you nail the simple moves, you can try your hand at longer ones.

Above: Keep it as smooth and slow as is feasible for your shot – the results will speak for themselves.
Opposite: The choreography and timing in this aerial sequence was very important as it would be hard to repeat the shot.

Subtle movements

Keep your camera moving smoothly by only making careful, slow and subtle adjustments. Be very calm and gentle with your sticks. Any jerky movement and you'll lose the shot. You need steadiness for at least seven seconds for it to be worth considering in the edit.

Practise

In the days before the shoot, get on your simulator to practise the movements you're planning to do. With some apps you can even record your simulated flight, which you can then pull into your edit to see how it would cut together with the rest of your film, which will be a very useful exercise.

The day before the shoot, try and go on location for a test flight. You'll be able to assess wind conditions and take into consideration the direction of the sun to avoid casting an unsightly shadow on screen. The aim is that, on the morning of the shoot, you'll know exactly how it's going to go down.

Get inspired

Watch as many films as you can to see what camera movements were used, and to which effect. To get you started, here are six must-see films for aspiring aerial photographers.

Above: Skimming over tree tops in Glacier National Park in this iconic shot from *The Shining*.

The Shining (1980)

The opening-credit sequence of Stanley Kubrick's seminal masterpiece is probably one of the most famous series of aerial shots in cinema history, and rightly so. Shot by Jeff Blyth from a helicopter, the shots were later shaped into a sequence packed full of symbolic foreshadowing of things to come in the movie.

Heat (1995)

In this cult thriller, arguably Michael Mann's best work, aerial establishing shots are used throughout to great effect, culminating in a central sequence where the two main characters, played by Robert De Niro and Al Pacino, meet for the very first time. The meeting is ominously presaged by a masterful nighttime aerial sequence shot by the second unit's helmer, David B. Nowell, during which Al Pacino's character is trying to track down the elusive thief played by Robert De Niro.

Above: A brooding sweep over Los Angeles in *Heat*.

Above: In *Planet Earth,* caribou run across the frozen tundra.

Above: Gliding with Canada geese in *Winged Migration*.

Above: *Sicario* crosses the border into a cartel inferno.

Winged Migration (2001/2)

This stunning feature documentary was directed by Jacques Cluzaud, Michel Debats and Jacques Perrin, and shot by director of photography Thierry Machado and thirteen additional cinematographers. It showcases the immense journeys made by birds during their migrations. The film was shot from ultra-light motor gliders, paragliders and hot-air balloons to create the feeling of being up there among the flying birds. It's also a great showcase for the sound design used to create the natural sounds up in the air – as of course, this could not be recorded from noisy gliders.

Planet Earth TV series (2006)

The BBC's groundbreaking series contains stunning aerial shots throughout, leading into each story by showing the grand scale of Earth's ethereal landscapes before moving in close. Shot from helicopters, planes and even hot-air balloons, it took over 50 hours of flight time to create.

Home (2009)

Another must-see for aspiring aerial photographers, this documentary by Yann Arthus-Bertrand shows our planet in key locations. It is almost entirely composed of aerial shots taken from a small helicopter flying across more than fifty countries, in order to show the diversity of life on Earth.

Sicario (2015)

Shot by master cinematographer Roger Deakins, *Sicario* is a stunning piece of action filmmaking. The film makes great use of aerial photography, all coming together in one breathtaking sequence about ten minutes into the film, showing an FBI raid across the Mexican border. This is brooding, raw, edge-of-the-seat filmmaking, using subtle off-tilts to add to the sense of unease, proving once again that Roger Deakins is one of the top cinematographers working today.

Cinematic camera moves for drones

Moving pictures have been made for well over a century and, partly thanks to ever-evolving technology, a number of camera moves have become industry classics. Great as they are in advancing the story, they have become part of a collective cinema knowledge for audiences worldwide.

Try to think more broadly than just 'aerials' for your drone. It can be your Steadicam, your crane or your dolly. There are camera movements that have evolved over a century of making cinema films. Adapted for drone work, these moves will elevate your work to a professional level – once you have mastered them, of course.

Pan

A pan simply moves your camera horizontally from left to right, or vice versa. Traditionally this is done on a tripod, so be extra careful to keep it steady and slow.
Uses: Tracking a moving subject horizontally; revealing a scene.

How: Start and finish on a still shot. Slow down your pan gradually and smoothly at the end, especially if you want a moving subject to retreat into the distance.

High pan

A variation of the pan is the high pan, essentially the same but from a much greater height – such as a shot slowly panning from the ocean to the steep, imposing coastal cliffs.
Uses: Long-shot tracking of a moving subject; a sweep around the landscape.
How: Start and finish on a still shot. Keep it slow, as you already have a lot in the frame.

Pan shot

Track shot

Tilt

Pointing the camera up or down (as opposed to lifting or lowering the drone).
Uses: Tracking a subject coming directly towards the camera and passing underneath; revealing a scene slowly in an upward tilt; letting a subject pass underneath and tilting up to follow it into the distance.
How: Always start on a still shot, move into the tilt and end on a still again. As always, slow and steady is the way to go.

Pedestal

Lifting or lowering the camera vertically in relation to the subject (as opposed to tilting).
Uses: Revealing the height of a subject. Use it to show a giant wind turbine or a tall building floor by floor.
How: Very steady does it. Lift (or lower) your drone steadily as you keep the camera pointing straight ahead. Start and end on a still frame.

Track

Also known as a truck or dolly shot, the track shot traditionally has the camera mounted on a cart (dolly) that runs on a track for smooth movement at a constant distance from and alongside the moving subject. Probably the most utilized camera movement in history, it's also the most versatile. Some define dolly shots more as front-on or follow shots rather than side-to-side shots.

Uses: Tracking of a moving subject; revealing of landscape features leading into a scene.
How: You can track anything, from slow tumbleweed blowing along desert sand to a fast vehicle or a herd of galloping horses. Keep it low. Try to keep obstacles (such as trees or tall grass) between you and the subject, to emphasize movement. You can also track along a row of static objects, such as a street or a row of trees.

Pedestal shot

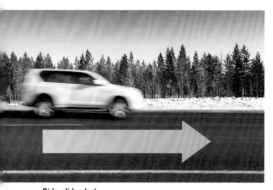

Side-slide shot

Follow shot

Follow

A cross between a dolly and a Steadicam shot, the follow shot does what it says on the tin: it follows the subject smoothly and steadily at a constant distance.

Uses: Tracking a moving subject; letting the subject lead us into a new scene.

How: Try to get much higher than your subject, and try and keep your subject framed like a medium shot. Keep it steady and smooth, making sure you know the pace at which your subject is moving before you start.

Side slide

Almost interchangeable with a track shot, a gamer might call this a 'strafe', as it allows the subject to move into the frame and exit the frame on the same trajectory.

Uses: Tracking of a moving subject; bridging story strands; showing the progression of time or the speed of a chase.

How: Starting with the subject out of frame, slowly let the subject enter frame while maintaining pace and altitude. Then let the subject slide across the frame and out the other side.

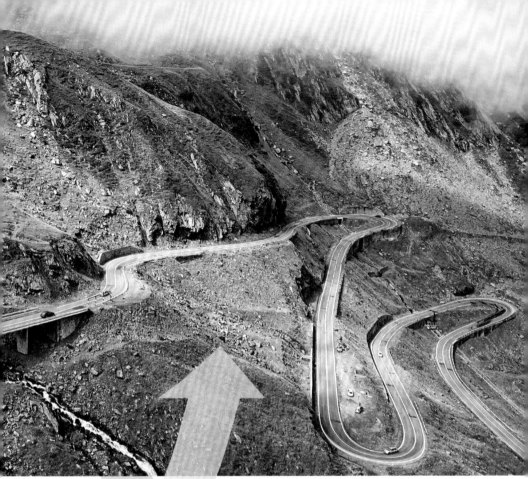

Crane shot

Crane

Differentiated by the 'rise up' and the 'fall down', the crane shot is epic in its simplicity, and most effective in transforming scenes. Along with the tracking and dolly shot, it has been a cornerstone of cinematic storytelling since the dawn of silent films. It enables you to move out of a scene and show the scale of the set, or draw you into a scene.

Uses: Leading into a scene, often with fall-down shots that go from a wider, higher viewpoint down into a medium or close up; moving out of a scene with the rise up to signpost the end of a sequence, or the end of the film.

How: Fall down – Start on a still image from higher up, slowly throttle down vertically as you slowly tilt the camera up to keep the subject within frame.

Rise up – Start on a still image and slowly throttle up as you tilt down the camera to keep the subject matter fixed within frame.

Variation – Once you've mastered a vertical crane shot, you can try a 3D crane where you move up (or down) and off to the side. This involves throttling up/down as well as yawing left/right to pan the camera.

Steadicam shot

Steadicam

Invented by Garrett Brown in 1975, the Steadicam brand has become synonymous with the camera stabilizer mount that mechanically, with the help of counterweights and a gimbal, isolates the camera from the operator's movement. It allows for smooth shots even when walking or running. Adapted for drones, it is one of the hardest shots to get right – do not attempt it until you are a competent pilot.

Uses: Steadicam shots are fantastic for staying close to your subject on uneven terrain, even at great speed. Best used for adrenaline sports such as mountain biking or skiing.

How: Start from stationary and move with your subject, keeping a close but constant distance either front on or from the back.

WARNING!

Because of the close proximity to your subject, always use prop guards when attempting this shot. Never use this shot with animals.

Keep it slow and keep it low

The slower you keep it, the more cinematic it will be. The lower you keep it, the less likely your footage will look like drone footage. Remember, your drone is a filming tool, not something you want to show off.

Reveal

Forward reveals are a great way to open a film and reveal something large, such as a mountain towering above a small village, a huge waterfall cascading into a river or a big port city after skimming along the surface of an ocean. Reverse reveals are better for showing a subject within the grand scale of the surrounds: you move from the reveal of the towering mountain to show the little village nestling at its foot.

Uses: The opening of a film, a scene or a sequence; the transition of a scene.

How: For the forward reveal, fly straight and steadily while slowly tilting your camera up to reveal your subject. For the reverse reveal, fly backwards and slowly tilt down to reveal your subject.

Reveal shot

Chase shot

Fly-by

A fly-by is not unlike a whip pan, or a fast version of an orbit-by. Even though it draws attention to the camera itself, it can be a playful way to show scale or speed.

Uses: To bridge one scene with another by leaving the subject behind; to show scale; for quick cuts.

How: Set up your framing beforehand. You need to know exactly how fast or slow your subject is moving in relation to your drone as you fly past the subject, and pan back to keep it within the frame. A fast fly-by requires a fast pan or tilt; a slow fly-by requires a slow pan or tilt.

Chase

This is very similar to a Steadicam, but often faster and thus even more dangerous for your subject, and very hard to accomplish. Instead of following your subject at a constant distance, you come up behind them and then fly past. In the edit, the cut would be at the point where the drone has caught up with the subject.

Uses: Quick cuts and action transitions.

How: Give yourself at least 20m (66ft) of distance so that you can get up to speed with the subject. Come up behind them steadily and move past them on either side.

WARNING!

Because of the close proximity with your subject, always use prop guards. Do not attempt this shot unless you are a competent pilot. Under no circumstances use this shot with animals – when shooting a horseback rider, for example.

Bird's eye

Bird's-eye shots are taken from high above, pointing the camera straight down. They are great for revealing scenery in an abstract way, or for conveying scale. Imagine a giant wind farm, shot straight from above. Bird's-eye shots are also ideal for never-seen-before angles on wildlife – whales or migrating animals, for example.

Uses: Transitioning between scenes; reflecting on the preceding scene; offering a slightly more abstract view of the subject; filming wildlife from high above. Also great for stills.

How: Point your camera straight down as you throttle the drone up. Make sure to keep the camera strictly at 90 degrees downwards, as this is what gives it a beautiful, abstract feel.

Bird's-eye shot

Fly-through shot

Fly-through

These shots are not to be underestimated. They are great to use as reveal shots, coming through tree tops to reveal the landscape behind, for example, or just for the sheer thrill and audacity of flying through gaps. This shot can be distracting because of the risks taken, however, so only use it when strictly necessary – otherwise it can take the audience out of the story.

Uses: Revealing scenery; transition between scenes.

How: Fly your drone straight through a gap, or a hole among obstacles, with your camera pointed forward. FPV is a must for this shot, as you won't be able to judge what you are doing if you're not looking at the obstacle straight on. Keep it as slow as possible for the best cinematic effect. Don't use it if all the shot does is show off the fact that you own a drone!

WARNING!

You must be a competent pilot to attempt this. There's a great risk that you will crash your drone, depending on how large the gap is.

Orbit

Orbits are great to reveal your subject among the scenery, such as a climber on a rocky spire in Bryce Canyon, or a couple of kids playing on a field as the camera orbits from above. An orbit is also technically the most advanced shot on this list, and takes a lot of practice to get right.

Orbit shot

Uses: Revealing the subject in an unexpected way; epic, grand-scale transitions.
How: Fly your drone sideways (strafe) left or right, while yawing in the opposite direction. This results in flying in a circle while keeping your camera pointed at the centre of the circle. It is crucial to be very careful with the yaw control, or you'll end up spinning. The larger the circle is, the slower the yaw will be. A good gimbal is essential, as is a constant yaw rate as well as constant adjusting of the forward, backward and sideways motion of the drone.

Orbit-by shot

Orbit-by

Essentially the slower version of a fly-by, the orbit-by is much easier to get right than a full orbit. It has a dynamic, active and sweeping feel to it, and is great to set up and establish characters and their environment before cutting to them on ground level. If you've done your on-the-ground filming and sound recording right (see below) you'll be able to use the ground-level audio here throughout.

Uses: Revealing the subject in an unexpected way; epic, grand-scale transitions.
How: Start off towards your subject a little off to one side, making sure the framing is perfect, and as you pass the subject, yaw to keep the subject within frame. As a consequence your drone will make a 180-degree turn, ending by moving out backwards, on the same trajectory as before (blue arrow) away from the subject.

The importance of on-the-ground B-roll footage

If you're serious about filming your subject properly, you need to think about B-roll footage on the ground, and even more importantly, good sound recording of location sound. The drone cannot capture sound at all, and it's a shame just to use music when you could have real location sound ('wild track' sound).

Second camera It's a good idea to take a second camera to get ground coverage and some audio of the same subject matter (ideally DSLR or MFT).
Tripod For the ground camera. Position it in a good vantage point and record the scene from there.
Shotgun microphone You'll instantly elevate your aerial footage if you record wild track sound and cut it under the aerial footage in the edit. You can't use the drone hum, anyway.
Audio (XLR) cables For the microphone.
Portable digital audio recorder To plug your microphone into. Alternatively there are stereo audio

recorders such as a Zoom H4N, which will do a great job of recording wild track of your flying environments.
Headphones To check levels and audio recordings.
Spare batteries Charged batteries for your camera, microphone and audio recorder.
SD cards MicroSD cards for the drone camera, second camera and audio recorder as well as back-up cards.
1T external hard drive If your shoot goes over a few days, you'll need bigger back-up drives. 4k cameras produce a huge amount of data.
Laptop To copy SD cards to the external hard drive.

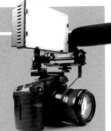
DSLR with shotgun microphone

Zoom Hn4 sound recorder

8 Photography

Taking stills photography from a drone is very different from shooting video. You express everything within a single frame, and the movement of video doesn't come into play. Therefore it's all about interesting compositions, unique subject matter and appropriate equipment that you know how to handle.

In this chapter we'll discuss:
- The stills-photography capabilities of GoPro and DJI cameras
- The best settings for action cameras
- How to fly bigger cameras without a gimbal
- Finding interesting subjects
- How to elevate your photography

Stills photography with drones

Although most action cameras are designed for video, some also offer decent stills-photography options, and that's as far as some aerial photographers want to go with their drones.

You might be a professional photographer with no need for footage, or you might want to take high-resolution photography to use as stills to market your film. To that end, the DJI Phantom 3 and 4 cameras and the GoPro Hero range offer decent, 12MP-still photography as well as 4k screengrabs. All share the same 1/2.3in sensor with a similarly fast f/2.8 prime lens.

Stills photography on GoPro Hero and DJI Phantom cameras

On the GoPro Hero3+, GoPro Hero4 and the DJI Phantom camera, there are several distinct photo-shooting modes, each of which is designed for different conditions.

Shooting mode

As you are working from a drone, single or continuous shooting modes will probably be your best options. Continuous shooting mode enables you to shoot stills manually in quick succession, which is very helpful from a moving drone. In this mode you also have the option to press and hold the shutter release for continuous bursts of up to ten images per second, depending on the individual camera.

Resolution

Use the highest quality available to make use of the full sensor. The amount of data is far less than shooting video, so you don't have to worry that the SD card might get maxed out

Stills feature	GoPro Hero3+	GoPro Hero4 Silver	Phantom 3 and 4
Maximum resolution for digital photos	10MP	12MP	12MP
Burst rates (frames per second)	3/1, 5/1,10/1	30/1, 30/2, 30/3, 10/1, 10/2, 10/3, 5/1, 3/1	3/1, 5/1, 7/1
Time-lapse intervals	0.5, 1, 2, 5, 10, 30 or 60 seconds	0.5, 1, 2, 5, 10, 30 or 60 seconds	
Continuous photo rates (frames per second)	N/A	10/1, 5/1, 3/1	N/A
Protune for photos	N/A	Yes	N/A
Night-photo mode	N/A	Yes	N/A
Night-lapse mode	N/A	Yes	N/A

too quickly. The highest resolution on Hero3+ is 10MP, on 4 it's 12MP and on the Phantom 3 and 4 it's also 12MP.

Protune/DNG RAW

If you desire complete manual control, select 'Protune' on GoPro or 'DNG RAW' on the Phantoms for best-quality photos with the highest dynamic range. You'll be able to colour correct in Photoshop later. You can also adjust the white balance, colour, ISO limit and sharpness. Protune is not available on the Hero3+.

Leave Protune off or don't choose RAW if you're happy to rely on the camera to automatically adjust these settings. The Phantoms also have auto-exposure bracketing (AEB), which means that the camera takes three or five images in quick succession with a range of exposures, so that the best can be selected afterwards or merged together for a high dynamic range (HDR) image.

Night-shooting mode

There is no built-in flash on these cameras, so GoPro's night-shooting mode is great in low-light situations such as dawn, dusk and urban night-time shots. Please note, though, that the darker the conditions, the longer the exposure will be, so do not shoot from a moving drone. Instead, hover in GPS hold – otherwise you'll get too much motion blur. The Phantom cameras can achieve similar results with exposure adjustment.

Left: Shot on GoPro Protune (RAW), this shot was subsequently colour graded (right).
Below: Low light and a higher ISO setting result in grainier footage, often softer and very atmospheric.

Time-lapse shooting/night-lapse shooting mode

Time lapse works best from a tripod, to record moving subjects such as cloudscapes, stars or traffic. Shooting from a drone inverts this concept, meaning that you're recording the drone's movement instead. The end result is like drone footage on fast forward. Needless to say, this needs a lot of practice to yield usable results.

Try shooting time-lapse scenes with traffic against the setting sun, with the added movement of the drone on a sideways crawl. When time lapse is selected, press the shutter once and the camera starts the sequence, taking photos at predetermined intervals. Stop the time lapse by pressing the shutter again.

Above: Night-lapse shots are hard to achieve from a drone due to the need to keep the camera still, but it is possible in favourable conditions.

Set the interval time to a fairly fast rate to account for the moving drone – around 0.5 or one second will be enough. Please note that this can only work from a drone if the movement is completely steady and very, very slow.

The night-lapse shooting mode is identical to time-lapse shooting, but works better in low-light conditions.

Using MFT and DSLR cameras for stills

When shooting on anything larger than a GoPro or integrated camera, the main problem is one of additional weight. But with the sole aim of taking stills, and not video, there are options for you to save the weight of a camera gimbal and use a simple bracket instead. This will allow you to fly a slightly heavier camera, but you will forsake the ability to control the camera separately.

This is not necessarily an issue if you work with a fast wide-angle prime lens. You can

Unique pictures and subjects

With the drone market booming, both traditional and social media have seen a flood of images taken from drones. These are often unique, but oversaturation is just around the corner. The onus is therefore on you to work on your compositions, find interesting angles and look at the interplay between shadow and light. Bird's-eye-view images have become particularly popular, so be careful not to overplay these.

Use the drone to get shots that you can't get from the ground, but at the same time, there's no need to take photos whose only USP is that they've been taken from a drone.

Find subjects that you feel have not been explored yet. Once you hit on something you're interested in, stick with it for a while until you feel you've found the best way to show off this subject.

predetermine the camera angle before take-off, then shoot either with the control monitor if your drone has FPV, or 'blindly'. The advantage of having a much larger sensor than standard integrated – or action – cameras will pay off with the quality of the photos.

Above: If you own a drone that can carry an MFT camera, you'll have much greater lens choice which will greatly help your photography.
Below: Careful framing and cropping, as well as unique angles, can greatly improve your work.

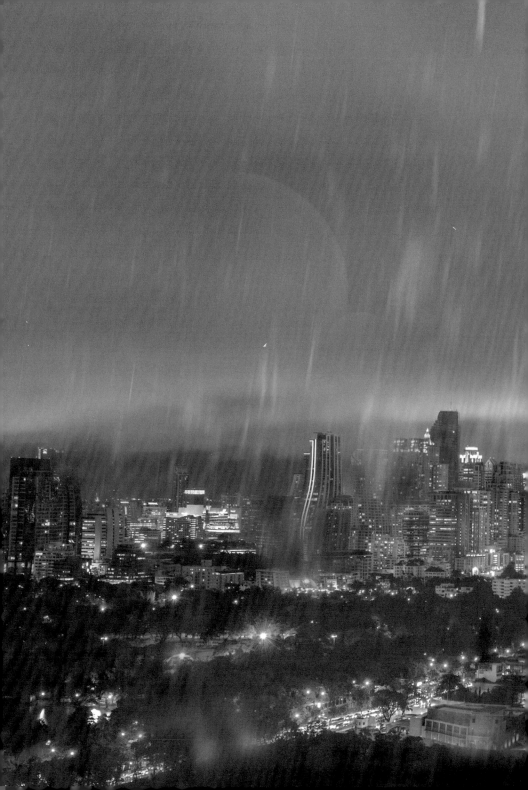

9 Flight environments

Every photographer or filmmaker is used to a certain type of environment – their home turf. And every environment has its own beauty, holds its own secrets and presents its own pitfalls and challenges. Once you've mastered basic drone photography you'll be itching to go further afield.

In this chapter we'll discuss:
- How to film in the mountains, on the water, and in rural and urban areas
- How to film wildlife and what ethical problems you'll have
- How to film night scenes

Rural areas

Even though the same laws apply in both rural areas and cities, practically speaking there's less to worry about in the countryside. Crowds are less of an issue, and there's less to damage should you crash your drone. Having said that, be aware of power and telephone lines, which won't take kindly to your buzzing drone.

Eliminating prop shadows

Around midday, when the sun is high in the sky, you may experience propeller shadows as you turn towards the sun. At just the right angle, the propellers can cast shadows onto your lens that will result in a flicker effect on your footage. You won't be able to eliminate it in post, so try and avoid flying towards the sun.

Rural areas are ideal for practising your flying skills and learning how to work your camera and gimbal setup. The environment is a little more forgiving should you make a mistake, and ideal for practising flying with waypoint mapping and long-range FPV.

Don't fly your drone over people, busy roads or highways. You cannot guarantee complete safety, and you're probably not appropriately insured should something go seriously wrong. Your drone's camera could infringe data-protection laws (filming people without permission) and might disturb other recreational visitors or local people.

Bring a spotter

Don't fly alone. You'll eliminate a lot of danger by bringing at least one friend along to act as your 'spotter'. Their job is to scan the sky and the ground for any obstacles that might pose a hazard and warn you in advance.

Make a plan

Discuss with your surfing friends how and what you are going to film, so that you don't annoy random strangers whom you wouldn't have permission to film anyway.

Familiarize yourself with your stretch of beach, watch the waves and the height of the spray zone and set up your base well away from other beachgoers.

Altitude and range

Keep an eye on your altitude and distance. Don't fly too far out, don't go whale watching and stay well within your range, or you run the risk of losing your drone. Pay close attention to the spray zone of the waves and don't go too low, especially if you are following the wave, or you'll endanger your drone.

Getting the shots

Before launching, use your drone handheld to capture a few shots of your friends getting ready. Make sure also to get some beach scenes, wide shots and close-ups so that you have full coverage of the day. It will be useful in the edit later.

Once launched, tracking the surfers as they glide along the waves is a great way to capture the drama and the beauty of the sport. Frame your shot, align the drone and start moving in advance, otherwise you'll lose the surfer. Stay in front or to the side of the wave as you film.

Try following a surfer as they move towards the beach, or from higher up. Also try bird's-eye views, as these are angles that are not often seen.

In the hot midday sun, your drone will heat up. You need to let it cool off after each flight – for ten minutes, at the very least.

In town

Flying drones in built-up areas will become increasingly restricted as laws are written or modified to clamp down on it. So if you must do it, it goes without saying that you must stay within the law as laid down by your local authority.

Above: When filming in a rural setting, stay away from busy roads or crowded squares.

Legally, there are two things that you need to worry about if you want to film aerial footage in a town or city: a piloting licence and filming permissions. These are two completely different issues and you need to look into each of them separately. If you don't obtain a piloting licence from the local authorities, then you shouldn't be doing any filming.

Public locations

Whatever urban location you're thinking of flying over, it is highly likely that you'll need to notify or get permission from somebody. Failing to inform the relevant authorities might result in the police being called out.

Be wary of assuming that a street is public when in fact it might be privately owned or managed. You need permission to fly and film in any public urban location, and you will usually be charged a fee. Don't fly anywhere near crowded squares and places.

Buildings

It doesn't infringe copyright if you're filming the exterior of a building, so for aerials you don't need to get the permission of the owners. Remember, though, to stay at least 50m (164ft) away from it.

Private land

To film in private locations such as residential properties or larger estates, you'll need to talk directly to the property owner or management company. Make sure you'll be able to stick within all the other rules regarding safety and privacy. And if you're thinking that this is a minefield, you'd be right.

Above: The principle of geo-fencing made visible.

Crew size

If you are filming with only a minimal crew (four or five people or fewer) and you don't cause an obstruction of any kind, most cities are fairly lenient and grant unrestricted filming in public spaces, provided that you've obtained the relevant flying licences. This could be different if you're also using a tripod-mounted camera.

Geo-fencing

A lot of authorities are campaigning for drones to be programmed not to enter certain airspaces. This is known as geo-fencing, and if you are the proud owner of a Phantom 4, it already includes it. Your GPS is programmed with thousands of airports around the world that you mustn't fly near or over. If you try and enter these areas, it will be forced to land. Within a radius of 2km (1.2 miles) of major airports, you won't be able to fly your drone higher than 10m (33ft). If you don't own a DJI drone, be careful to stick to these rules.

Above: Early mornings or evenings are great for capturing atmospheric footage in a quiet, suburban neighbourhood.

Rules and regulations

- Privately or commercially, you must never fly beyond your line of sight – 500m (1,640ft) horizontally and 120m (394ft) vertically.
- You must stay at least 50m (164ft) away from a person, vehicle, building or structure.
- You must not fly within 150m (492ft) of a congested area or a large group of people, such as a concert, demonstration or sporting event.
- For commercial purposes, you must have permission to fly a drone from your relevant aviation authority (the FAA in the US or the CAA in the UK).

Animals and wildlife

We've all seen stunning footage of migrating animals in African wildlife reserves or a polar bear with her cubs teetering on an ice float. This is now completely achievable with a consumer drone. But does it help the animals?

Above: Since this footage was shot in the Kruger National Park in South Africa, the country has clamped down on all drones in South African wildlife reserves.

There is no doubt that drone photography will further our understanding of the last remaining wild places on Earth. Drones are already used to check on animal populations, and the WWF has plans to deploy them in African wildlife parks to find and track poachers. The Orangutan Conservancy in Malaysia and Indonesia uses drones to map and count primate populations and monitor wildfires. These are uses for drones that directly effect change – for the better.

Ethics

However, the popularity of drones is beginning to worry a lot of outdoor purists. Is it ethical to buzz over a herd of mustangs to capture them in magnificent 4k slow-motion as they stampede across the Nevada sagebrush? Or drive a flock of sheep with their week-old lambs up the Sussex Downs with a quadcopter? No, it certainly is not. But it does look awesome on screen. And there's your impasse.

Respect the wildlife

Research has found that animals conditioned to predation from above, such as turkeys or waterfowl, see a drone as a predator. Flight animals with strong herd instincts – antelopes, wild horses and even elephants – react visibly to drones and take flight quickly. On the other hand, larger predatory animals not wired to fear birds of prey don't seem to care all that much. As you try and capture some footage of wildlife, hopefully respectfully and responsibly, please remember that you are flying your drone over their home turf. They need their space and territory to remain just that – wild. Make sure to stay over 20m (66ft) above them, and do not chase them if they run away. Their safety should be your biggest concern.

Be ready at dawn

Be ready at your launch site at first light. Launch at least a few hundred metres away from where you want to film, so that, by the time you fly over your subjects, you are at a safe height and make the least noise possible. Most animals are active at dawn, and the light and the mood, often with added morning mist floating on the ground, will be at its most striking.

Right: Using wild track sound recording with your drone footage will instantly set it apart from all the drone shots set to music.

Recording wild track

Always remember that anything you film with your drone won't have usable sound – all you hear is the annoying buzz of the motors. The solution is either to add music (something of a lazy trick) or to record actual sound to underlay in the edit. A nature film without nature sounds is only half the experience.

After filming your footage, come back even earlier the following morning with a good sound recorder, a microphone and a tripod such as the bendable Joby Gorillapod. Set up your recorder as close as possible to where you filmed the previous day; if it's bendable you can tighten it to a tree branch or similar so that wildlife won't step on it. Check that the recording levels are even and start recording.

Now retreat back a safe distance and wait. Let it record for as long as possible, at the very least for 30 minutes, but ideally longer. Hopefully you'll have captured some animal voices and birdsong identical to what was there the previous morning when you were filming.

Once you have done the first recording, spend a few hours in the area and record anything of interest – the murmuring of a stream, a waterfowl taking off, birds of prey. The idea is that you'll be able to use some of this and match it to your images from the previous day. When it works, it is absolutely magical.

Night-time flying

Flying your drone at night is a whole new experience. Often there's little or no wind, your drone becomes a blinking light in the night sky and LOS can even be easier than during bright daylight hours. But what of video capabilities? And are you even allowed to fly?

The first thing to say about flying your drone at night is – **don't do it**! That's what most experienced drone pilots would tell you, and that's definitely the most sensible thing to advise. Having said that, we need to discuss what is doable, as well as what isn't doable, as there are definitely occasions when night flying and filming would come in very handy.

It's a legal minefield up there

You're not allowed to fly your drone at night in cities such as London, Paris, Los Angeles or New York unless you apply for a special licence. City councils worldwide are clamping down on night-time drone flights. There have been too many incidents of drones being spotted over sensitive areas, and with the

constant threat of terrorism, it's not something that you want to be caught up in.

Always check the regulations and laws in your area before flying, day or night. Don't fly in residential areas – it's hard to avoid breaking privacy laws and you really don't want to antagonize the whole neighbourhood. Stick to the regulations on page 84.

Night filming in rural areas

Practically speaking, you can *fly* your UAV at any time of day or night, even in pitch darkness, but *filming* with your UAV at night requires a modicum of light. If you're flying in nature or rural areas, you really need to stick to dawn or dusk. The only light source in nature at night is a starry sky or moon, or the blinking red lights on top of giant wind turbines. But that won't be enough for most consumer drone cameras.

At the very least, you need a larger sensor and faster lenses. If your drone can fly MFT cameras such as the Panasonic GH4 or Sony's a7R, boasting a full-frame 35mm sensor, you'll be much better equipped.

Night filming in urban environments

Brighter-lit urban environments are a much better bet if you want to try filming at night. While earlier DJI Phantoms were really not great for night-time conditions, the Phantoms 3 and 4 get decent results. Always keep movement very slow and steady, otherwise you'll get motion blur at the longer exposure times. Play around with the settings. GoPros are better, but you need to find the right settings (*see* box, right). Stick to non-residential and non-governmental areas. Absolutely no airports!

Left: A night-time sequence shot over Rio de Janeiro with the Phantom 4 turned out beautifully because of the perfect mix of last daylight and ambient city lights.

Time lapse or night lapse

Night-time is fantastic for stunning time lapses – think firework displays or busy roads. Find the best settings for night-time stills photography on your camera (*see* page 124) and do some tests on the ground to find a good medium for your camera settings. Then start with a sequence from a hover, for example near – never above! – some busy traffic. Shoot a one-minute time lapse and check the results. If it's usable, try a very slow-moving sequence. Set the image rate to one image per second. Try a very slow crawl with a very slow pan, pre-set to avoid frame shake through manual handling.

Go from there, and you'll be amazed at the stunning images you can shoot.

Camera settings for video

Phantom 3 and 4
These settings are only an approximation. They completely depend on the light conditions where you are, so you will need to experiment.
Resolution: 4k or 1080p
White balance: 3000K or try LOG RAW
FPS: 24fps
Shutter speed: 50 (As a rule of thumb, shutter speed should be around twice the frame rate.)
ISO: Start at 400. If that's too low, increase incrementally to 800 and 1600. Above 1600 the results might become too grainy.

GoPro Hero3+ and 4
Resolution: 2.7k
Protune: On
White balance: 3000K or try CAM RAW ('Native' on Hero4)
FPS: 24fps
ISO: Start at 400. If that's too low, increase incrementally to 800 and 1600. Above 1600 the results might become too grainy.
Sharpness: Low
Exposure: +0.0 (You can adjust up or down by .5 if you want additional control.)

10 The edit

Once you have shot your first footage, you'll want to be able to edit it together and understand how to stabilize it. You'll also realize – if you haven't already – that all the sound from your drone is unusable. Here we teach you in more detail how to create your own.

In this chapter we'll look at:
- Editing software – what's right for you
- Stabilization software
- How to import your footage
- Sound effects and music
- Colour grading

Non-linear editing (NLE) software

To cut your beautiful aerial footage into a narrative, to stabilize vibrations and to add sound and music, you'll need editing software, a stabilizer, sound effects and music – but first and foremost, a willingness to engage with something that looks painfully complicated and boring. That is, until you understand the basics.

There's a lot of non-linear editing (NLE) software out there, from open-source freeware to top, pro-level packages – but everything has a price, even when it's free. After purchasing a high-tech aircraft equipped with 4k and spending days honing your aerial filmmaking skills, the last thing you'll want to do is cobble something together with freeware that doesn't have any support. So here are the five best legit packages for you.

Consumer level
iMovie, Windows Movie Maker and Adobe Premiere Elements are NLEs supported by global brands Apple, Microsoft and Adobe, which means you'll get updates and support.

Windows Movie Maker ★★★
MICROSOFT'S FREE BEGINNER NLE

 Platform: Windows
 Formats: Any Windows-compatible media format
 Features: Ultra-easy user interface, quick to cut clips, add transitions, set up audio tracks, easy to export finished video, HD support, storyboard mode, one video track and two audio tracks, linear timecode display
 In short: Simple, free tool to quickly create video content
 Price: Free

iMovie ★★★★
APPLE'S VERSATILE BEGINNER NLE

 Platforms: Macintosh and iOS
 Input formats: QuickTime compatible with HD support, and 4k
 Output formats: QuickTime compatible with HD support
 Features: Extremely popular Apple-based NLE for all Mac devices, including iPhone and iPad, NDE, HD support, two video tracks and four audio tracks, linear timecode display and storyboard mode
 In short: Much more advanced than Windows Movie Maker, it offers a lot of spec'd down, pro-level features.
 Price: $14.99*

iMovie

Windows Movie Maker

Adobe Premiere Elements ★★★★
ADOBE'S VERSATILE BEGINNER NLE

Platforms: Macintosh and Windows

Input formats: Adobe Shockwave Flash, DV stream, H.264, MPEG-1 and 2, QuickTime, DVD video, Windows Media and 4k

Output formats: H.264, MPEG-1, QuickTime, DVD video, Windows Media and 4k

Features: Motion titles, tutorials and 4k output, two working modes – 'Quick' and 'Expert'

In short: Best pro-level features at a low price

Price: $94.00* (free 30-day trial)

Pro-level

Final Cut Pro X and Adobe Premiere Pro are arguably the two most popular professional NLEs at present. They are one step below Avid Media Composer, which is the go-to software for most professional editing suites but comes at a much higher price tag.

Final Cut Pro X ★★★★★
APPLE'S PROFESSIONAL NLE

Platforms: Macintosh

Input formats: Any QuickTime-compatible format, and more

Output formats: Any QuickTime-compatible format

Features: HD and 4k support, storyboard mode, non-destructive editing, up to 99 video and audio tracks, very intuitive interface, too many pro features to list, used by professional indie editors worldwide

In short: Best Mac-based NLE on the market

Price: $299*

Lock & Load

Even with the best gimbal, you probably won't get shake-free footage. There's a lot of stabilizing software on the market, but as most of them are reasonably cheap, you should go for the best. Final Cut Pro and Premiere Pro both include stabilizing filters, but CoreMelt's Lock & Load works much better, faster and more smoothly, with far fewer of the unsightly side effects of stabilizing software. Check compatibility with your editing software to see how Lock & Load integrates.

Original shot Stabilized with Lock & Load

Adobe Premiere Pro ★★★★
ADOBE'S PROFESSIONAL NLE

Platforms: Windows, Macintosh and Cloud

Formats: Most video formats

Features: Multi-track editing, HD support, storyboard mode, unlimited audio and video tracks, linear timecode display, seamless integration with After Effects (VFX) and Photoshop, all expected pro-level features

In short: Multi-platform compatible all-round professional editing platform

Price: $25.00* per month on subscription – one-year commitment, with 20GB cloud storage included

* Prices differ from country to country and are given here in US dollars to give a rough, global guide

The basic editing process

Once you've understood the basic process for editing, you'll quickly progress. Editing is essentially quite simple, but seems dauntingly complex at first. It's a bit like cooking. You start with a couple of ingredients – video and sound. Once you have cooked them into a coherent narrative, you spice it up with sound effects, music and maybe visual effects. Voilà!

Making a film, even a two-minute clip, involves tons of files, so you need to get a system in place and stick to it. This is really important for NLE management.

We're gonna need a bigger hard drive

Video files, especially HD or 4k, are very large compared to, say, 10MB holiday photos. 24fps video files contain 24 medium-resolution frames *per second*. So a one-minute clip contains 1,440 images – a little more than you'd take on a summer holiday. If you shoot 30fps or 60fps, it will go up exponentially. As you can see from the table below, you can quickly rack up a few hundred gigabytes of data if you shoot in 1080p or 4k.

With ever-cheaper data storage solutions, you should purchase three hard drives (HDs):
• One portable HD of 1TB (terabyte)
• Two identical larger HDs of 2TB or 4TB each.

The portable 1TB HD will be your portable field HD to back up all your drone footage. Make sure you label the folders carefully with the date and the location.

The first 2/4TB HD is your 'live' server. Here you'll keep all your converted video, audio and editing files.

The second 2/4TB HD is your backup. On here, you'll store your original drone footage, as well as a backup copy of your live server footage. Alternatively you can use a 'cloud' service for your backup.

1TB portable HD

4TB G-RAID HD

Codec	Res	FPS	Size/min	Size/hour
H.264	720p	24fps	120MB	7.3GB
H.264	1080p	24fps	359.7MB	21.08GB
ProRes	4k	24fps	712MB	42GB
RAW	2.5K	24fps	7.2GB	432GB
RAW	UHD	24fps	12.36GB	741.6GB

Get organized

Now that you've got your storage sorted, you need to organize your assets. When you open a new project in your NLE and import your clips into it so that you can edit them together, the program remembers where the clips are stored on your HD. For example, if all your clips are stored in a folder called 'flight _03_sucked' then forevermore the NLE will link to it, in order to display them. If you rename the folder, the links will be lost and you'll have to re-link all the clips. Therefore it makes sense to think about your logical naming convention and stick with it.

Here's an example:

After you've created your folder structure, copy all your files into the relevant folders.

Importing, transcoding and logging

When you start a new project in your NLE, you'll need to give it properties according to how you want to use it afterwards. If you're editing a project with mixed-format media – 99 per cent of the time, the media will be mixed – and you intend to share it as 1080p HD, you should set your project's video properties to 1080p HD, with 48KHz audio.

Once you've set up a new project – let's call it 'My First Flight' – you import your clips from the folder Sat_10-11-16. The NLE might give you the option to transcode on import, which means that it will give all the imported clips the same properties as your project. This will make the edit much quicker by cutting down rendering times.

You can also use external apps such as Any Video Converter or Handbrake to batch-transcode all your source files before import. Once you've imported your clips, you can add metadata to each clip and sort them into folders. This means that, during the edit, you can find a clip in a folder or search for it using metadata keywords you've added, such as 'pan left', 'landing' or 'sunset'.

Left: Importing your clips into your project library varies slightly from NLE to NLE, but the principle is the same.

Audio conversion

What applies to video files, also applies to audio. You'll need to convert all audio files to 48KHz to match the properties of your project.

Editing

Start by dragging your first clip from your library onto your timeline. You'll see that it is comprised of video and audio. As it's a drone-camera clip, you can discard the audio straight away, as it will just be the engine noise. Depending on your NLE, you should be able to 'separate audio from video' and then just delete the audio part.

Now you can trim your video to cut off anything you don't want at the beginning and end. Then add the next clip. In this way you string a few clips together, one after the other. And that's your first edited video right there, albeit without sound.

Below: Dragging clips onto your NLE timeline, you can start experimenting with how you want to fit the shots together sequentially.

Transitions

Every edited video has cuts between shots. Cuts can be 'hard', so that one shot changes immediately to the next, or they can be 'soft', which means they blend into one another. This is called a transition.

You can use fancy transitions such as wipes, cross-fades or cross-dissolves – anything you want. To begin with, keep it simple. Fancy transitions quite quickly get annoying to watch.

Right: The Transitions panel in Final Cut Pro.
Below: A simple cross-fade transition.

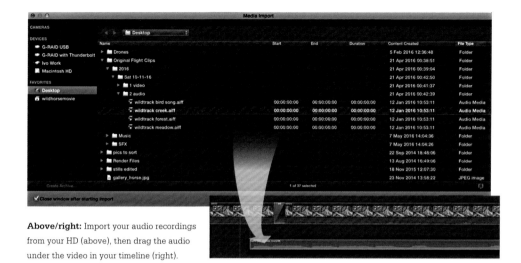

Above/right: Import your audio recordings from your HD (above), then drag the audio under the video in your timeline (right).

Adding wild track sound

Remember how you recorded that wild track (*see* page 137)? Now's the time to use it. Import your converted audio files and put them in an audio folder.

Now look at your video carefully. If you're showing an aerial shot of a creek, for example, find the audio file where you recorded that creek. Drag it under the video part and fit it. Now, as you play it back, you should see a gentle floating shot across the creek, and you can hear it too. Isn't that magical? Fade the audio in and out to match it to the visual.

Do this for every part of the video and soon you'll have an amazing aerial sequence, with matching audio. No one would guess that the two weren't recorded at the same time.

Right: Make sure that you hold the copyright for anything you put on YouTube or other media-sharing sites.

Don't infringe copyright!

In this era you could be forgiven for thinking that everything you find online is free. Buying music is so last century – now you stream it for fractions of pennies and you can watch free HD content anywhere. The internet creates the illusion that everything is free – only it's not. The creators are always the ones paying the price.

Anything that someone creates is their copyright, and it's up to you to respect that. It's just about fine to use a music track you haven't yourself created in your own clip, if it's for home use only. The moment you upload it to a content-driven, monetizing site such as YouTube, you are infringing someone's copyright even if you yourself are not being paid for the clip. It doesn't matter, so don't do it.

broadcasting a segment on sustainable energy. Wait – that's *your* beautiful aerial shot of that giant wind farm! Remember how you slaved to get that shot, at dawn, after days of getting up at 4am? And here's a factual content producer hoping you wouldn't notice. It happens all the time. Don't be that person.

SFX

Once you've added your sound, there may well be instances where you're missing something. For example, the sound of a car driving past below. You can source almost anything you want from sound-library websites. Find the noise of a car driving past, download it and put it in a folder labelled 'SFX'. Import it into your NLE. Fit it with the shot of the car, and you're done.

Adding music

Lastly, you want to add music – this will truly get your aerials to lift off. Find something you think will work, import the sound file and drag it under your audio tracks.

Depending on your piece of music, maybe fade it in gently. Keep the volume low – don't drown out all your beautiful wild track. Or if you think it best, only add music to some parts, or just the closing credits.

Left: Sound files (green) normally reside below the NLE timeline, with the video files above (blue). Add a couple of sound files to your sequence and you'll instantly see how transformative sound can be.

Adding titles and credits

Depending on your NLE, you'll probably have a lot of presets for titles and credits. Look through the text-style options and drag a couple onto the timeline to see how they work. There'll be various options, some more and some less stylish – try to decide which one will stand the test of time – and go for it.

If you had a few friends that helped you with the shoot, now is the time to give them a credit, or a thank you. Find a simple credit-scroll preset and scroll their names across that aerial of the setting sun – it'll blow their minds.

Above: Text files reside above the video files on the timeline, so that they're not blocked out by the video.

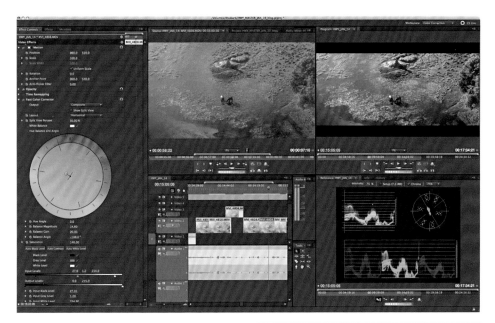

Colour grading

If you've shot in RAW, or GoPro Native, then your colours will still be quite flat. Remember, we did this so that you now have the option to fine tune all the clips so that they have the same look, saturation and hue.

Colour grading is time consuming and takes a lot of skill. Don't expect to get it right first time – there are highly paid graders who do this for a living.

Start by fixing any white-balance issues. Perhaps the WB wasn't set the same on every clip. Scroll through your timeline and find any clip that doesn't look like the others. Adjust the WB in the colour menu of your NLE. Once all the clips look the same, you can apply an overall 'look'.

All NLEs have a colour-corrector tool for exposure, saturation, hue and sometimes contrast. Experiment on just one clip until you're happy with the look. Then you can either replicate the look, or with a lot of NLEs you can copy and paste the effects to all the other clips.

Top: The Fast Color Corrector effect in Premiere Pro is easy and effective, and a great starting point to tackle any shot.

Above: Final Cut Pro X's colour correction panel is simple and very effective.

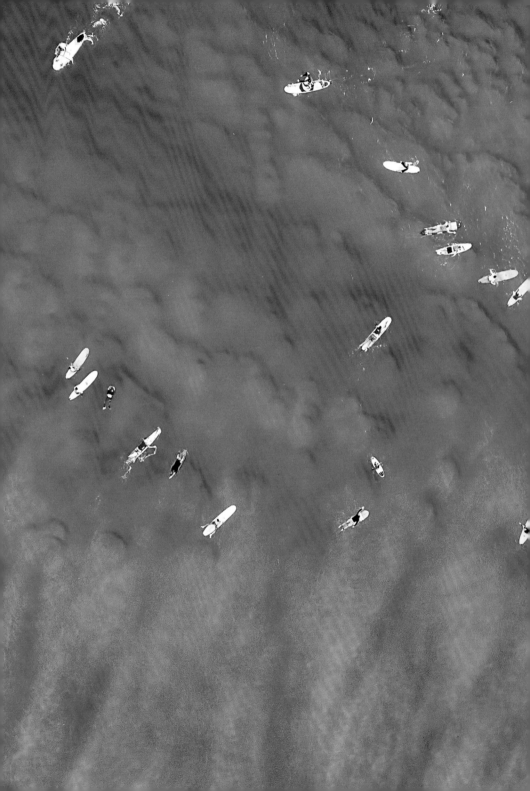

11 What's next?

Once you've created several drone films and feel confident in your abilities, you may be at a stage where you feel you're ready to take it to the next level: getting your film out there or selling your aerial footage on stock libraries.

In this final section we'll look at:
• Media-sharing websites
• Stock libraries
• Drone- and adventure-film festivals
• How to become a professional drone cameraman

Media-sharing websites and festivals

There are endless ways for you to get your work out there, and the internet provides an amazing, worldwide platform. But before you put your work online in beautiful HD, remember to read the small print.

There's a multitude of user-generated, media-sharing websites where you can publish your work. YouTube, Facebook, Metacafe or Dailymotion are easy and free to use, and can give a lot of free storage and exposure.

Because these sites have millions of users, they also have millions of visitors – meaning that they make their revenue via advertising, which is why you get to use them for free. Just make sure you're clued up about copyright first (*see* page 147).

Vimeo

Sites for filmmakers

Vimeo and similar sites are great for hosting high-quality HD content from indie producers. You can upload your films, anything from a 30-second clip to a feature film, and then decide on the level of privacy, password protection and sharing options. You'll be able to receive comments from friends and become part of a worldwide filmmaking community.

Drone film festivals

With the booming drone market, related film fests have sprung up everywhere. These are events where filmmakers showcase their camera skills, and winning entries are often stunning aerial narratives that don't primarily rely on words to tell a story.

One of the most significant events is EpicTV and DJI's Rise of the Drones Festival in October, which will hopefully become one of the annual events to look forward to.
Website: epictv.com/festivals

Some of these festivals are quick to be formed, and equally quick to disband. Your best bet is to search the internet for the most up-to-date drone festival events and dates.

Best adventure-film festivals

Adventure documentaries have gained a big following over time, with Austria's Red Bull Media House a prominent producer of high-production-value content. This in turn has given rise to adventure-film festivals all over the globe. Even though these events were initially largely set up to celebrate daring feats, they have broadened their appeal considerably over the years. Here are the best of the best:

Sheffield Adventure Film Festival, UK
★★★★
The networking hub
The ShAFF is held over one weekend in March, screens over 100 films from all over the world and is a great place to connect with like-minded people.
Website: shaff.co.uk

Why Not? Adventure Film Festival, Ireland ★★★
The boutique adventure fest
The WNAFF is a small, annual adventure-sports-documentary festival on the beautiful west coast of Ireland, held in late September.
Website: whynotadventurefilmfestival.com

Edinburgh Adventure Film Festival, UK ★★★★
The Scottish adventure weekend
The EMFF is held annually in February as the main Scottish festival for adventure-sport films. It's well run by passionate people, with great participants and speakers.
Website: emff.co.uk

Telluride Mountain Film, US ★★★★★
America's best adventure festival
Held annually in May in this skiing town in Colorado, this is probably the best adventure-film fest in America. After the main event, the best entries go on a worldwide tour.
Website: mountainfilm.org

Above: Watching your own film in a cinema with like-minded people is an exhilarating experience.

Kendal Mountain Festival, UK ★★★★★
The Oscars of adventure film
Kendal is the biggest adventure-film fest in Britain. Held annually in November, its international film competition attracts premieres from around the world – it's been called the 'Oscars of outdoor filmmaking'.
Website: mountainfest.co.uk

NZ Mountain Film Festival, New Zealand ★★★
Adrenaline films in Adrenaline City
Held in July, the NZMFF is held over five days in stunning adrenaline hubs Queenstown and Wanaka, featuring screenings, events and an international film competition.
Website: mountainfilm.net.nz

Banff Mountain Film Festival, Canada ★★★★★
The mother of adventure film fests
With forty years of adventure, the BMFF is the original stalwart, and probably the biggest festival of them all. Held in October, it is the perfect place to meet the adventure-film elite in an informal setting.
Website: banffcentre.ca

Working as an aerial cinematographer

With countless flying hours under your belt, your HDs brimful with beautiful aerial shots and some videos of your home turf on Vimeo, you may wonder if there is a way to do this professionally.

Given that drone technology is still developing at a rapid rate, it's a good time to get involved professionally, especially if you have one foot in aerial photography and the other foot on the ground pursuing 'traditional' cinematography.

Identify what type of filming you'd like to do, and find the best camera–drone combination you can afford. The DJI Inspire 1 with integrated MFT camera would be a great starting point.

Licence and qualifications

Join your country's flying association or a similar body to access great resources. You'll find insurance for public liability and all the information on no-fly zones, as well as anything else you'll need to know to become registered. Consider taking flying lessons, even if you have already taught yourself flying – they might iron out habitual mistakes. Applying for a licence differs from country to country.

US

The Federal Aviation Authority (FAA), the issuing body for drone licences, is in the process of updating the regulations for UAV pilots, and new regulations are due to be issued by mid-2016 (it may take longer). At the time of writing, you still need to apply for a '333 exemption' through the FAA if you want to fly drones commercially. But this only allows you to make money as a drone owner. In order to commercially fly one, you currently need to hold a crewed pilot's licence. This is what the FAA is revising, as these regulations were issued before drones were even invented. It's the equivalent of having to hold an 18-wheeler truck licence in order to ride a scooter.

The quickest and cheapest way to get a pilot's licence is to take ballooning lessons and get a ballooning certificate, which is accepted by the FAA. I know, right?

The 333 exemption will currently take at least five months, so the sooner you get in line, the quicker it will be. Go through a reputable agent such as uavcoach.com and you'll get your exemption for US $1,500. The ballooning certificate will unfortunately set you back about another $5,000. As a rule of thumb, don't expect to pay less than $7,000 all in, excluding your drone and camera.

UK

In the UK there are a number of CAA-approved National Qualified Entities (NQEs) that you can go through to do your training and

Above: The real-estate industry offers a lot of opportunities for professional drone pilots.

qualifications: EuroUSC Ltd; Resource Group Ltd; Rheinmetall Technical Publications UK Ltd (RTP-UK); and Sky-Futures Ltd.

At the end of the training, you need to pass a Pilot Competency Flight Assessment. You are tested on your operating procedures and your ability to fly, including dealing with emergency scenarios. You'll need to be insured for the flight test for public liability, professional indemnity and accidental damage cover.

Once you have passed, you need to get your operations manual verified and apply to the CAA for permission for aerial works. Your insurance will be invalid without this permission and you will need to work under the CAA guidance that legislates the use of small unmanned aircraft.

It takes about four months from start to finish and will cost around £2,000, excluding drone and camera.

Above: Drones have been used to help monitor wildfires, although this is not accessible for private operators.

Above: Commercial agriculture has an ever-increasing need for aerial monitoring.

Jobs

Once you are up and running, the sky is literally the limit. There's great potential to do aerial work for cinema and TV productions, and equally there's increasing demand in the property business working for estate agents.

It really depends where you live. In the US, most 333 exemptions have been issued in Florida and California, known for property development and movie production respectively. In mountainous regions you might be able to carve out a niche as a mountain aerial cinematographer. Look at where you live, and see what the region needs in terms of aerial photography.

Resources

Drone resources

uavcoach.com
One of the most comprehensive websites in the field. UAV Coach offer a buying guide, online UAV pilot training, mapping and modelling, industry news and drone jobs.

diydrones.com
DIY Drones offer thousands of useful articles plus the latest drone news, updates and trends in the DIY drones community.

oscarliang.net
Oscar Liang is one of the most prolific drone bloggers, writing about multicopters and RC-hobby and drone electronics in amazing depth.

myfirstdrone.com
Korey Smith runs My First Drone, where he probably has an answer to every drone question you might have.

droneflyers.com
An awesome drone forum plus news, reviews and helpful beginners' guides.

bestquadcoptersreviews.com
If you're unsure what drone is best for you, this site will have an answer.

dronelife.com
Dronelife is another great review and updates site on everything drone.

quadcopters.co.uk
This is one of the best UK-centric drone sites and suppliers, with regular updates and news for their customers.

Aviation authorities and the law

UNITED KINGDOM
caa.co.uk
Regulations and guidance on the safety rules that apply when flying unmanned and model aircraft, as well as everything you need to know to become commercially registered.

UNITED STATES
faa.gov/uas
The website for the Federal Aviation Authority.
faa.gov/uas/faq
The FAA's frequently asked questions page.
ncsl.org/research/transportation/current-unmanned-aircraft-state-law-landscape.aspx
The National Conference of State Legislatures website on everything regarding US drones law.

EUROPE
easa.europa.eu/easa-and-you/civil-drones-rpas
All regulations and laws for drones in Europe.

AUSTRALIA
casa.gov.au/aircraft/landing-page/remotely-piloted-aircraft-system
The website for the Australian Civil Aviation Authority.

NEW ZEALAND
caa.govt.nz/rpas/
The website for the Civil Aviation Authority of New Zealand.

Glossary

Accelerometer – device measuring acceleration forces, used to stabilize drones

ARF – almost ready to fly – newly purchased drone that still requires some easy assembly

Auto-follow system – drone capable of following a body-worn GPS device

Autonomous flight – independent flight via GPS and waypoints

Balanced battery charger – charger using smart technology to charge battery cells and balance them

Bind – connecting the controller (transmitter) with the drone

BNF – bind 'n' fly – drone ready to 'bind' to your existing transmitter

Brushless motor – highly efficient, durable and lightweight magnetic motor used with most quadcopters

Build – unit built at home as opposed to store-bought

Camera gimbal – camera holder with the capability to tilt and swerve

Controller – handheld device that controls the drone, also called a transmitter

CPU – central processing unit

CSC – combination stick command

ESC – electronic speed controller – device that controls an electric aircraft's motor, connecting the RC receiver and main battery

FC – flight controller – computer that controls functions of your drone

FPV – first-person view – camera mounted on drone to let the pilot see what the drone sees, in real time

Geo-fencing – virtual barrier to 'fence off' no-fly zones such as airports and government buildings

Gimbal – device that keeps an instrument such as a camera level and stable in a moving aircraft

GLONASS – *globalnaya navigatsionnaya sputnikovaya sistema* – Russian satellite system

GPS – global positioning system – used to track the position of an object in relation to satellites

Gyro or gyroscope – device that measures angular velocity and helps maintain orientation

HD – hard drive – for data storage

HD video – high-definition video

Hexacopter – multirotor aerial vehicle with six rotors

Home point – GPS fix that the drone obtains when first switched on, often used as return to home (RTH) point

IMU – inertial measurement unit – controller with accelerometers and gyros that help orientation, navigation and stabilization

LiPo batteries – lithium polymer batteries

LOS – line of sight – flying the drone by visual contact

mAh – milliamp hours – the available current that can be provided by a battery for one continuous hour

MFT – micro four-thirds camera

Multirotor – aircraft with multiple rotors

NLE – non-linear editing software

Octocopter – eight-rotor drone

Payload – amount of weight the drone is able to lift in addition to itself and its batteries

Pitch – forwards/backwards momentum

POI – point of interest – Phantom 4 feature that lets you designate any point in the landscape as a POI to circle the drone around

Quadcopter – four-rotor drone

RAW – photo format that contains all the uncompressed picture information

RC – radio controlled

Roll – bank left/right

RTF – ready to fly – the unit is sold ready to fly

RTH – return to home

Telemetry – flight data passed between drone and controller

Throttle – up/down

UAV – unmanned aerial vehicle

Ultrasonic sensor – sensor that uses ultrasound to map the ground below

VFX – visual effects

SFX – sound effects

Waypoint – location defined by a set of co-ordinates

WB – white balance

Wild track – location sound, also known as wild sound or wild recording

Yaw – quadcopter rotation around its centre axis

Index

Acknowledgments

T = top, C = centre, B = bottom, L = left, R = right;
4-5 © Olga Kashubin/Shutterstock.com;
6 T photography/Shutterstock.com; 7 s_bukley/
Shutterstock.com; 8-9 Patty Chan/Shutterstock.com;
10-11 prochasson frederic/Shutterstock.com; 12T
© PF-(sdasm1)/Alamy Stock Photo, 12B © Mass
Communication Specialist 3rd Class Kenneth G. Takada;
13T © Joseph Janney Steinmetz, 13B © Pinosub/
Shutterstock.com; 14B ©DJI, 14T © dpa picture alliance
archive/Alamy Stock Photo; 15T © Jag_cz/Shutterstock.
com, 15B © r.classen/Shutterstock.com; 16T © vitals/
Shutterstock.com, 16C ©DJI, 16B ©DJI; 17T ©Traxxas,
17B © seregalsv/Shutterstock.com; 18T © Dosunets
design/Shutterstock.com, 18C © Aliexpress.com, 18B
© AutoQuad; 19T RealVector/Shutterstock.com, 19B ©
3D Robotics; 20T © CPdesign/Shutterstock.com, 20CL
A-R-T/Shutterstock.com, 20C © robin2/Shutterstock.
com, 20CR © springart/Shutterstock.com; 20B ©
Henglein and Steets/Getty Images; 21T © pbk-pg/
Shutterstock.com, 21C © RealVector/Shutterstock comp
© Mariusz Szczygiel/Shutterstock.com, 21B © Feijutech;
22 © Hubsan; 23T © UdiR/C, 23B © Parrot; 24 ©
DJI, 25 © DJI; 26T Revell, 26B © Parrot; 27T © Erle
Robotics, 27B © marekuliasz/Shutterstock.com; 28-29 ©
Mariusz Szczygiel/Shutterstock.com; 30 © Parrot; 31T ©
Peter Sobolev/Shutterstock.com, 31BL © aerogondo2/
Shutterstock.com, 31 BR © Elvid; 32T © Fat Shark;
32B © sezer66/Shutterstock.com; 33T © Jarp2/ .
Shutterstock.com, 33C&B Epson, 34T © BNMK0819/
Shutterstock.com, 34B Parrot; 35T&B Flysight; 36T ©
JR PROPO, 36B © Teradek; 37 DJI; 38C © The Urban
Ant, 38B-1 © air808, 38B-2 © Omnivision, 38B-3 ©
Flysight; 40BL © Fat Shark, 40BR © Kletr/Shutterstock.
com; 41T © Yuneec, 41B © DJI; 42T © Charlotte Lake/
Shutterstock.com, 42B © Peter Sobolev/Shutterstock.
com; 43 © marekuliasz/Shutterstock.com; 44T ©
marekuliasz/Shutterstock.com, 44B A. Aleksandravicius/
Shutterstock.com; 45T © marekuliasz/Shutterstock.com,
45B © Tomislav Pinter/Shutterstock.com, 46L © AirDog;
47TL © Hexo+, 47TR Strahil Dimitrov/Shutterstock.
com, 47B © AirDog, 48-49 © Pavel L Photo and Video/
Shutterstock.com, 48B © Tayzu Robotics, 49T © Liquipel
& DSLRPros.com; 50T © DJI, 50B Fouad A. Saad/
Shutterstock.com, 51T © Maksim Vivtsaruk/Shutterstock.
com, 51B © zvukmedia/Shutterstock.com; 52 © kelt-md/
Shutterstock.com, © Wonderful'Pixel/Shutterstock.
com, © Aha-Soft/Shutterstock.com; 53 © Robert M/
DIY Drones; 54-55 © Jag_cz/Shutterstock.com , 54T
© marekuliasz/Shutterstock.com, 55T © Stefan Holm/
Shutterstock.com, 56-57 © Shutterstock.com; 58T ©
Lukas Gojda/Shutterstock.com, 58B © Revell; 59T ©
Parrot, 59B © DJI; 60 © Dronevlieger/Shutterstock.
com, 61T © DJI, 61BL © Peter Sobolev/Shutterstock.
com, 61BR © marekuliasz/Shutterstock.com; 62-63
© Vronska/Shutterstock.com, 62B © seregalsv/
Shutterstock.com, 63T © AirDog; 64T © Flying3D, 64B
© Ionic Stratus; 65T © 3D Robotics, 65B © Hexo+;
66T © Walkera, 66B © AirDog; 67T © DJI; 68-69 ©
Alexander Kirch/Shutterstock.com, 69 © GoPro; 70 ©
Sergey Uryadnikov/Shutterstock.com, 70B © XiaoMi
Mi; 71T © Pavel L Photo and Video/Shutterstock.com,
71B © SJCAM; 72T © DJI, 72B © Panasonic; 73T ©
Olympus, 73B © Yuneec; 74T © Alexander Kolomietz/
Shutterstock.com, 74B © Blackmagic Design; 75 © DJI;
76-77 © Miks Mihails Ignats/Shutterstock.com; 78T ©
Peter Sobolev/Shutterstock.com, 78B © 3D Robotics;
79T © marekuliasz/Shutterstock.com, 79B © toozdesign/
Shutterstock.com; 80T © DJI, 80B marekuliasz/
Shutterstock.com, 81 © DJI; 82TL © marekuliasz/
Shutterstock.com, 82TR © Tyler Olson/Shutterstock.
com, 82B © marekuliasz/Shutterstock.com; 83T ©
Leonid Eremeychuk/Shutterstock.com, 83C © Santyaga/
Shutterstock.com, 83B © kelt-md/Shutterstock.com;
84 © Yuriy2012/Shutterstock.com, © Diamond P/
Shutterstock.com, © veronchick84/Shutterstock.com,
© musicman/Shutterstock.com, © Irmun/Shutterstock.
com, © Dshnrgc/Shutterstock.com; 85TL © VoodooDot/
Shutterstock.com, 85TR © FloridaStock/Shutterstock.
com, 85C Altana8/Shutterstock.com, 85B © Shirstok/
Shutterstock.com; 86-87 © Miks Mihails Ignats/
Shutterstock.com; 88 Golden Sikorka/Shutterstock.
com; 89T © Tatiana Popova/Shutterstock.com, 89B
© 90miles/Shutterstock.com; 90 © Shutterstock.
com, 91T © DJI, 91B © Tatiana Popova/Shutterstock.
com; 92 © Tyler Olson/Shutterstock.com; 94-95 ©
Vladimir Melnikov/Shutterstock.com, 96 © DJI, 97T
© DJI, 97B © DK.samco/Shutterstock.com; 98-99 ©
Gustavo Frazao/Shutterstock.com; 100 © Kolidzei/
Shutterstock.com, © Vasilyev Alexandr/Shutterstock.
com, © toozdesign/Shutterstock.com, © Gilmanshin/
Shutterstock.com; 101T © marekuliasz/Shutterstock.
com, 101BL © Yothinw/Shutterstock.com, 101BR ©
Seregam/Shutterstock.com; 103T © Shutterstock.
com, 103B © Mikhail Varentsov/Shutterstock.com;
104B © Vladimir Melnikov/Shutterstock.com, © DJI;
106-107 © e2dan/Shutterstock.com; 108 © B Brown/
Shutterstock.com; 109 © skapuka/Shutterstock.com;
110T © sezer66/Shutterstock.com, 110B © Steve
Boice/Shutterstock.com, 111TL © Rolf_52/Shutterstock.
com, 111TR © Vladimir Melnik/Shutterstock.com,
111BL © Rudmer Zwerver/Shutterstock.com, 111BR ©
Frontpage/Shutterstock.com; 112 © Andrey Armyagov/
Shutterstock.com, 113T © Vadim Petrakov/Shutterstock.
com, 113B © Fahkamram/Shutterstock.com; 114T ©
Iakov Kalinin/Shutterstock.com, 114B © Carsten Medom
Madsen/Shutterstock.com; 114-115 © Thomas Zsebok/
Shutterstock.com; 116T © sportpoint/Shutterstock.
com, 116B Tappasan Phurisamrit/Shutterstock.com;
117T logoboom/Shutterstock.com, 117B © Stockr/
Shutterstock.com; 118T © Scott Prokop/Shutterstock.
com, 118B © William Cushman/Shutterstock.com;
119T © nopporn/Shutterstock.com, 119C © Hoika
Mikhail/Shutterstock.com, 119B © Zoom; 120-121 ©
Joseph Sohm/Shutterstock.com; 123T © photomatz/
Shutterstock.com, 123B © saraporn; 124T © ssguy/
Shutterstock.com; 125 © Panasonic, 125B © akphotoc/
Shutterstock.com; 126-127 © Orapin Joyphuem/
Shutterstock.com; 128-129 © Alexey Lobanov/
Shutterstock.com, 129T © Erwin Niemand/Shutterstock.
com; 130T © Roman Tarasevych/Shutterstock.com,
130-131 © SJ Travel Photo and Video/Shutterstock.
com; 132-133 © AerialGrom/Shutterstock.com, 133B ©
nbiebach/Shutterstock.com; 134T © Peteri/Shutterstock.
com, 134B © macro-vectors/Shutterstock.com; 135
© Jacek_Kadaj/Shutterstock.com; 136 © Vadim
Petrakov/Shutterstock.com; 137 © Kjetil Kolbjornsrud/
Shutterstock.com; 138 © Scott13/Shutterstock.com;
140L © Aeraw/Shutterstock.com, 140-141 © Vladimir
Melnikov/Shutterstock.com; 144L © Lacie, 144R
G-RAID; 150-151 © David Bostock/Shutterstock.com;
152L © phoelixDE/Shutterstock.com; 154 © Tyler Olson/
Shutterstock.com, 155TL © TI/Shutterstock.com, 155R
© Alexander Kolomietz/Shutterstock.com, 155C © Tyler
Olson/Shutterstock.com, 155B © N. F. Photography/
Shutterstock.com

The author

With an MA in Screenwriting from the Royal Holloway University in London, **Ivo Marloh** has written a number of feature films, including *Magic Boys*, an international co-production starring Michael Madsen and Vinnie Jones. Ivo has since written and produced several award-winning films. In his latest, an adventure documentary feature shot in Mongolia over three years, (allthewildhorsesmovie.com), he uses a lot of the drone technology he writes about in this book. He now divides his time between filmmaking, screenwriting and guest-lecturing on both subjects at numerous universities around the world.

Foreword

Capturing the essence of adventure in more than 60 extreme films has taken Emmy award-winning cameraman and filmmaker **Keith Partridge** to some of the world's most hostile and spectacular environments. Working on everything from documentary feature films such as Joe Simpson's *Touching the Void* to TV work such as the BBC's *Human Planet* and *Wild Climbs*, Keith has always pushed the limits of extreme filmmaking. Productions in which he's been involved have won dozens of international film awards, two BAFTAs and an international Emmy. His award-winning book *The Adventure Game*, charting his experiences in filming at the ends of the Earth, was published in June 2015.

Editorial consultant

Michael Sanderson completed a Broadcast Engineering and Film Technology BA and Documentary Filmmaking MA degree, leading to work in wildlife filmmaking at BBC Bristol. He has since become one of the leading wildlife drone camera experts. He has built various multi-rotor aerial copters himself and with improving technologies has pioneered the flying of heavier cinema cameras. His film *De Nieuwe Wildernis* won multiple awards for cinematography.